Nikon® Creative Lighting System Digital Field Guide

Nikon® Creative Lighting System Digital Field Guide

J. Dennis Thomas

Nikon® Creative Lighting System Digital Field Guide

Published by Wiley Publishing, Inc. 111 River Street Hoboken, N.J. 07030-5774 www.wiley.com

Copyright © 2007 by Wiley Publishing, Inc., Indianapolis, Indiana

Published simultaneously in Canada

ISBN: 978-0-470-04527-5

Manufactured in the United States of America

10987654321

1K/RZ/RS/QW/IN

No part of this publication may be reproduced, stored in a retrieval system or transmitted in any form or by any means, electronic, mechanical, photocopying, recording, scanning or otherwise, except as permitted under Sections 107 or 108 of the 1976 United States Copyright Act, without either the prior written permission of the Publisher, or authorization through payment of the appropriate per-copy fee to the Copyright Clearance Center, 222 Rosewood Drive, Danvers, MA 01923, (978) 750-8400, fax (978) 646-8600. Requests to the Publisher for permission should be addressed to the Legal Department, Wiley Publishing, Inc., 10475 Crosspoint Blvd., Indianapolis, IN 46256, (317) 572-3447, fax (317) 572-4355, or online at http://www.wiley.com/go/permissions.

LIMIT OF LIABILITY/DISCLAIMER OF WARRANTY: THE PUBLISHER AND THE AUTHOR MAKE NO REPRESENTATIONS OR WARRANTIES WITH RESPECT TO THE ACCURACY OR COMPLETENESS OF THE CONTENTS OF THIS WORK AND SPECIFICALLY DISCLAIM ALL WARRANTIES. INCLUDING WITHOUT LIMITATION WARRANTIES OF FITNESS FOR A PARTICULAR PURPOSE. NO WARRANTY MAY BE CREATED OR EXTENDED BY SALES OR PROMOTIONAL MATERIALS. THE ADVICE AND STRATEGIES CONTAINED HEREIN MAY NOT BE SUITABLE FOR EVERY SITUATION. THIS WORK IS SOLD WITH THE UNDERSTANDING THAT THE PUBLISHER IS NOT ENGAGED IN RENDERING LEGAL, ACCOUNTING, OR OTHER PROFESSIONAL SERVICES. IF PROFESSIONAL ASSISTANCE IS REQUIRED, THE SERVICES OF A COMPETENT PROFESSIONAL PERSON SHOULD BE SOUGHT. NEITHER THE PUBLISHER NOR THE AUTHOR SHALL BE LIABLE FOR DAMAGES ARISING HERE-FROM. THE FACT THAT AN ORGANIZATION OR WEB SITE IS REFERRED TO IN THIS WORK AS A CITATION AND/OR A POTENTIAL SOURCE OF FURTHER INFORMATION DOES NOT MEAN THAT THE AUTHOR OR THE PUBLISHER ENDORSES THE INFORMATION THE ORGANIZATION OF WEB SITE MAY PROVIDE OR RECOMMENDATIONS IT MAY MAKE. FURTHER, READERS SHOULD BE AWARE THAT INTERNET WEB SITES LISTED IN THIS WORK MAY HAVE CHANGED OR DISAP-PEARED BETWEEN WHEN THIS WORK WAS WRITTEN AND WHEN IT IS READ.

For general information on our other products and services or to obtain technical support, please contact our Customer Care Department within the U.S. at (800) 762-2974, outside the U.S. at (317) 572-3993 or fax (317) 572-4002.

Wiley also publishes its books in a variety of electronic formats. Some content that appears in print may not be available in electronic books.

Library of Congress Control Number: 2006936754

Trademarks: Wiley and the Wiley Publishing logo are trademarks or registered trademarks of John Wiley and Sons, Inc. and/or its affiliates. Nikon is a registered trademark of Nikon, Inc. All other trademarks are the property of their respective owners. Wiley Publishing, Inc. is not associated with any product or vendor mentioned in this book.

About the Author

J. Dennis Thomas, known to his friends as Denny, has been interested in photography since his early teens when he found some of his father's old photography equipment and photographs of the Vietnam War. Fortunately, he was able to take photography classes with an amazing teacher that started him on a path of learning that has never stopped.

Denny's first paying photography gig was in 1990 when he was asked to do promotional shots for a band being promoted by Warner Bros. Records. Although he has pursued many different career paths through the years, including a few years of being a musician, his love of photography and the printed image has never waned.

With the advent of digital photography, although he was resistant to give up film, Denny realized there was yet more to learn in the realm of photography. It was just like starting all over. Photography was fresh and exciting again. Realizing that the world of digital photography was complex and new, Denny decided to pursue a degree in photography in order to learn the complex techniques of digital imaging with the utmost proficiency.

Eventually Denny turned his life-long passion into a full time job. He currently owns his own company, Dead Sailor Productions, a photography and graphic design business. He does free-lance work for companies including RedBull Energy Drink, Obsolete Industries, Secret Hideout Studios, and Digital Race Photography. He still continues to photograph bands, including LA Guns, the US Bombs, Skid Row, Quiet Riot, Echo & the Bunnymen, Dick Dale, Link Wray, and Willie Nelson. He has been published in several regional publications and continues to show his work in various galleries throughout the country.

Credits

Project Editor Cricket Krengel

Technical Editor Michael D. Sullivan

Copy EditorJerelind Charles

Product Development Supervisor Courtney Allen

Editorial Manager Robyn B. Siesky

Vice President & Group Executive Publisher Richard Swadley

Vice President & Publisher Barry Pruett

Business Manager Amy Knies **Project Coordinator** Erin Smith

Graphics and Production Specialists LeAndra Hosier Jennifer Mayberry Brent Savage

Quality Control Technician Brian H. Walls

Proofreading Ethel M. Winslow

Indexing Stephen Ingle

This book is dedicated to my family.

To Hunter and Dylan, Mom, Dad, Diana, Tami, and the rest...

Acknowledgments

hanks to Jack Puryear at Puryear Digital Photography, Robert and Jerry at Precision Camera and Video in Austin, TX, Julia Czech at Wet Salon in Austin, TX, the faculty and staff at Austin Community College, all the bands and models, Cricket, Courtney, and Tom at Wiley Publishing, and especially to Ashley for supporting me while I undertook this project.

Contents at a Glance

Acknowledgments ix Introduction xix Quick Tour 1
Part I: Using the Creative Lighting System. 7 Chapter 1: Exploring the CLS 9 Chapter 2: Setting Up the SB-600 and SB-800 29
Part II: Creating Great Photos with the Creative Lighting
System
Chapter 3: Flash Photography Basics
Chapter 4: Wireless Flash Photography with the CLS
Chapter 5: Setting Up a Wireless Studio
Chapter 6: Real-World Applications
Chapter 7: Simple Posing for Great Portraits
Part III: Appendixes
Glossary
Appendix A: Resources
Index

Contents

Introduction

Quick Tour 1

Getting Up and Running Quickly
Taking Your First Photos with the
Speedlight

Part I: Using the Creative Lighting System 7

Chapter 1: Exploring the CLS 9

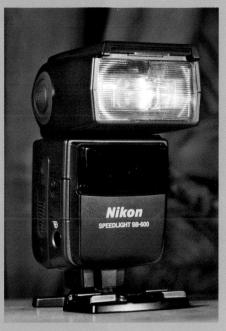

Features of the Nikon Creative	
Lighting System	
SB-800	10
SB-800 specs and features	10
Main parts	12
Control buttons	15
SB-800 accessories	17
SB-600	
SB-600 feature overview	
Main parts	18
Control buttons	21
SB-600 accessories	23

Other Components of the Creative		Auto Aperture	32
Lighting System	23	Non-TTL Auto flash	3
Camera compatibility	23	Guide number distance	
D50	25	priority	3.
D70/D70s	25	Repeating flash	3:
D200	26	Setting Up for the Creative	
D2X/D2Xs and D2H/D2Hs	26	Lighting System	34
SU-800 Commander	26	Commander	34
SBR-200 Speedlight	27	Wireless remote flash	34
		SB-600	3!
Chapter 2: Setting Up the SB-6	500	SB-800	3!
and SB-800 29		Sound	3
		SB-600	3
. /	PRESSOR	SB-800	30
The same of the sa		Zoom position	3
Carried .	- Keeping	SB-600	30
111111		SB-800	3
		Channels	3
the same of the sa		Setting groups	3
120		Adjusting output	
		compensation – on camera	38
		Adjusting output	
		compensation – wireless	
		mode	39
a la	//	D70/D70s	39
	1	D200	40
The state of the s	A CONTRACTOR	SB-800	40
		SU-800	40
		Locking controls	
		SB-800	
Power Requirements	29	SB-600	
Non-rechargeable	30	Red-eye reduction	42
Rechargeable	30	A.F. Assist	4

SB-600 SB-800

Part II: Creating Great Photos with the Creative Lighting System 47

Chapter 3: Flash Photography Basics 49

Speedlights versus Studio Strobes	49
Basics of Lighting	53
Studio lighting	53
Placement	53
Basic Portrait lighting	
types	56
Using Speedlights outdoors	60
Color Temperature and White	
Balance	62
What is Kelvin?	62
Preset white balance	62
Using Bounce Flash	66
When to use bounce flash	67
Camera and Speedlight	
settings	69
Explaining Flash Exposure and	
Specifications	70
Guide number	70

Aperture	71
Distance	71
GN ÷ Distance = Aperture	73
Sync Speed	73
Fill flash	73

Chapter 4: Wireless Flash Photography with the CLS 75

How CLS Works with Your Camera	76
Overview of Flash Setup in the CLS	76
Step 1: Choose a Flash mode	77
Step 2: Choose a channel	77
Step 3: Set up groups	77
Step 4: Adjust output levels	78
Setting Up Masters and Remotes	78
D70/D70s as a master	78
D200 as a master	79
SB-800 as a master	80
Setting Up Flash Modes	80
SB-800 in Master mode	81
Using a built-in Speedlight	81
Setting Channels	82
SB-800 in Master mode	82
Using a built-in Speedlight	82
Wireless remote flash	82

Setting Up Groups	83
SB-600	84
SB-800	84
Setting Output Level Compensation	84
With the SB-800 set to Master	84
Using a built-in Speedlight	85

Chapter 5: Setting Up a Wireless Studio 87

Introduction to the Portable Studio	88
Choosing Umbrellas	88
Using a Softbox	90
Flash-mount softboxes	90
Stand-mounted softboxes	90
Softbox alternatives	91
Backgrounds and Background	
Stands	92
Seamless paper backdrops	92
Muslin backdrops	93

Canvas backdrops	94
Background stands	95
Space Requirements	95
Setting up indoors	95
Portraits	95
Small products	102
Setting up outdoors	102
Traveling with Your Wireless Studio	103
Camera cases and bags	103
Backgrounds and light stands	104

Chapter 6: Real World Applications 107

Action and Sports Photography	107
Inspiration	109
Action and sports	
photography practice	111
Action and sports	
photography tips	112
Animal and Pet Photography	113
Inspiration	113
Animal and pet photography	
practice	115
Animal and pet photography	
tips	116
Concert Photography	117
Inspiration	118
Concert photography	
practice	119
Concert photography tips	121
Event and Wedding Photography	121
Inspiration	123

Event and wedding	
photography practice	124
Event and wedding	
photography tips	126
Environmental Portrait	120
Photography	126
Inspiration	128
Environmental portrait	120
photography practice	129
Environmental portrait tips	131
Group Photography	131
	132
Inspiration	
Group photography practice	133
Group portrait photography	
tips	135
Macro and Close-up Photography	135
Inspiration	137
Macro and close-up	
photography practice	138
Macro and close-up	
photography tips	140
Nature and Wildlife Photography	140
Inspiration	142
Nature and wildlife	
photography practice	143
Nature and wildlife	
photography tips	144
Night Portrait Photography	145
Inspiration	146
Night portrait photography	
practice	147
Night portrait photography	
tips	148
Outdoor Portrait Photography	149
Inspiration	150
Outdoor portrait	
photography practice	151
Outdoor portrait photography	
tips	152
Still Life and Product Photography	153
Inspiration	154
Still life and product	
photography practice	155
photography practice Still life and product	
photography tips	156

Studio Portrait Photography	157
Inspiration	158
Studio portrait photography practice	160
Studio portrait photography	
tips	162

Chapter 7: Simple Posing for Great Portraits 163

Posing Basics	163
Refined Posing Techniques	165
Positioning the	
midsection	165
Positioning the arms and	
hands	166
Positioning the head and	
neck ⁻	167
Positions to Avoid	171
Planning Poses	171
Casual portrait posing	172
Traditional poses	173
Photojournalistic poses	173
Glamour style	174

Part III: Appendixes 177 | Appendix A: Resources 185 Glossary 179

nformational Web Sites	185
Workshops	186
Online Photography Magazines and Other Resources	186
Index	189

Introduction

hen Nikon introduced the Creative Lighting System, it was mostly overlooked. The focus was on the rapidly changing advancement of digital SLR cameras. This disregard was a shame because the Nikon Creative Lighting System was the most amazing development to happen to photographic lighting in decades. The ability to infinitely control the output of multiple lights *and* to be able to do it wirelessly, without the need of an expensive light meter was unheard of.

Even now, the praises of the Nikon CLS are largely unsung. Other companies have tried to replicate the Nikon CLS with marginal success. Nikon simply offers more options and a wider variety of accessories. With the SB-800, the SB-600, the SU-800, the R1, and the R1C1, no other company comes close to offering such a multitude of tools for specific lighting needs.

The main feature of CLS is the ability to get the flashes off of the camera and to be able to control them wirelessly. When you're stuck with the flash mounted on the camera or even to a flash bracket, your ability to control the lighting is severely impeded — leaving you stuck with full frontal lighting.

With the CLS, you can direct the light. Thus, you can create the same lighting patterns that professionals achieve with expensive studio strobes, at a much lower cost. This is the key to professional-looking images: controlling the lighting to get the effect you want.

The Evolution of the Nikon CLS

Nikon started toying with wireless Speedlight control in 1994 with the introduction of the SB-26 Speedlight. This flash incorporated a built-in optical sensor that enabled you to trigger the flash with the firing of another flash. While this was handy, you still had to meter the scene and set the output level manually on the SB-26 itself.

With the release of the SB-28 in 1997, Nikon dropped the built-in optical sensor. You could still do wireless flash, but you needed to buy the SU-4 wireless sensor. Wireless flash still had to be set manually because the pre-flashes used by the TTL metering system caused the SU-4 to fire the Speedlight prematurely.

In 1999 Nikon released the SB-28DX; this flash was made to work with Nikon's emerging line of digital SLRs. The only change from the SB-28 was the metering system. The Nikon film-based TTL metering was replaced by DTTL. This metering system compensated for the lower reflectivity of a digital sensor as opposed to film's highly reflective surface.

XX Introduction

In 2002 Nikon replaced the SB-28DX with the SB-80DX. The changes were minimal, more power, wider zoom, and a modeling light. They also returned the wireless optical sensor. As before, although you could use this Speedlight wirelessly, you still had to set everything up on the flash itself.

When 2004 rolled in, Nikon revolutionized the world of photographic lighting with the SB-800, the first flash to be used with the new Creative Lighting System. The first camera to be compatible with the CLS was the D2H. Using the D2H with multiple SB-800s enabled you to control the Speedlights individually by setting them to different groups, all which were metered via pre-flashes and could be adjusted separately.

With the introduction of the D70 and later the D70s and D200, users could even control any number of off camera Speedlights using the camera's built-in flash. Of course using the built-in flash had some drawbacks. Using the D70s, you can only control one group of Speedlights, and with the D200, you can only control two groups. Even so, this is remarkable. Never before could you use a Speedlight off camera while retaining the function of the iTTL metering.

Eventually, Nikon augmented the CLS line with the SB-600, the little brother to the SB-800. While lacking some of the features of the SB-800, such as the ability to control Speedlights, it's still an amazing little flash. Nikon also released a couple of kits for doing macro photography lighting, the R1 and R1C1. The R1 macro lighting kit has two small wireless Speedlights, the SBR-200, which you can mount directly to the lens via an adaptor. The SBR-200 can also be purchased separately enabling you to use any many lights as you want. The R1C1 kit is essentially the same as the R1 kit, with the addition of the SU-800 commander unit. The SU-800 is a wireless transmitter that enables you to control groups of flashes just like the SB-800 without a visible flash. The SU-800 can control any of the Speedlights available in the CLS line, the SB-800, the SB-600, and the SBR-200.

What's in This Book for You?

While the manuals that come with the Speedlights are informative and contain all the technical data about your Nikon Speedlight, they don't exactly go into detail about the nuances of lighting — the small things and pitfalls you may encounter or the types of settings you might want to use on your camera and lenses.

That's where this book comes in. This book offers you tips and advice acquired in real world situations by a photographer who has been using the Nikon Creative Lighting system almost daily since it was first introduced.

Initially, flash photography is often thought of with dread as mysterious and confusing. However, with this book I hope to dispel that myth and help to get you on the road to using the flash and CLS as another creative tool in your photographic arsenal, rather than something to be avoided at all costs.

Quick Tour

any cameras come equipped with a built-in flash. Like any photographer who takes many photos with flash, you soon learn the limitations of these built-in flashes. In order to obtain better flash lighting for portraits, still lifes, and other types of photography, the next step is to graduate to external Speedlights, such as the Nikon SB-600 or SB-800. By adding Speedlights to your photographic arsenal, you get many further-reaching photographic capabilities your built-in flash just can't provide.

Nikon Speedlights are very easy to use right out of the box. All you need to do is unpack what's in the box, insert AA batteries, attach the Speedlight to your camera's hot shoe, turn on your flash and camera, and you are ready to start taking photos! Though many would think that advanced flash units such as the SB-800 or SB-600 are complex beasts, the reality is, they are ready-to-go for quick snapshots, but also configurable for some complex wireless multi-flash photo shoots. So get ready, you are about to explore the world of the SB-800 and SB-600 Speedlights and the Nikon Creative Lighting System.

This quick tour shows you how to get up and going with your SB-800 or SB-600 Speedlight to take great flash photos immediately.

In This Chapter

Getting up and running quickly

Taking your first photos with the Speedlight

Getting Up and Running Quickly

If you want to get up and running quickly with your Nikon Speedlight SB-800 or SB-600, all you really need to do is insert the batteries, attach the Speedlight to your camera, and then turn both the Speedlight and the camera on. You'll be amazed at the quality of flash photos you can take with the Speedlight as soon as you take it out of the box.

The flash accepts Alkaline, Lithium, or rechargeable AAsized batteries

To attach the Speedlight:

- Turn off the camera and Speedlight. Both the Speedlight and camera should be turned off before attaching. Turning off the equipment reduces any risk of short-circuits when attaching different electronic devices.
- Unlock the mounting foot lock lever. Move the mounting foot lock lever of the SB-800 to the left – its unlocked position.
- Attach the Speedlight to your camera. Slide the Speedlight hot shoe into the camera's hot shoe. Turn the mounting foot lock lever to the right to lock the Speedlight in place.
- 4. Position the flash head to the horizontal position. When you first attach the Speedlight to your camera, make sure the flash head is positioned in its normal horizontal position. You can reposition the flash head by pressing the flash head tilting/rotating lock release, and then positioning the flash head.

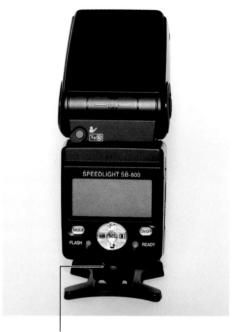

Mounting foot lock lever (unlock position)

QT.1 Turn the mounting foot lock lever to the left to unlock.

When using the SB-800, if the flash head is not in the normal, horizontal position, the LCD panel shows a warning.

- 5. Turn on your camera.
- Turn on your Speedlight. The On/Off switch for the Speedlight is located on the back panel, shown in figure QT.4.

After you power up your Speedlight and camera with the flash head in the horizontal position, both the flash and camera sync. You can then reposition the flash head to your desired position.

QT.2 Position the flash head in the horizontal position by pressing the flash head tilting/rotating lock release.

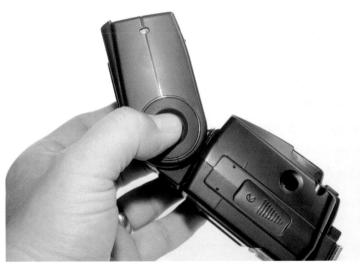

QT.3 Repositioning the flash head.

Modeling Illuminator button

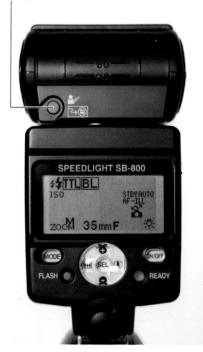

QT.4 The back of the SB-800 Speedlight

Tip

The SB-800 comes equipped with the SW-10H diffusion dome. When you place the diffusion dome over the flash head, you get a more subdued, softer light on your subject. Consider using the diffusion dome when shooting portraits of people or even when you want to soften the light on other subjects such as a floral arrangement.

Taking Your First Photos with the Speedlight

After you get your flash attached and turned on, the flash default sets itself to TTL mode. TTL stands for Through the Lens, which means that the light meter in the camera takes a reading through the lens and decides how much flash exposure you need depending on your camera settings.

- If your camera meter is set to matrix metering, which means the light meter is taking a reading of the whole scene, you see BL after the TTL icon. The BL stands for balanced fill flash. The camera adjusts the flash exposure to match the ambient light, creating a more natural look.
- If your camera is set to spot meter the scene, the flash sets to full TTL mode. The camera's meter takes a reading of the subject and exposes just for that, not taking into account the background light.

I recommend setting your camera to matrix metering mode and using the TTL BL mode. This mode produces great results and you don't have to do anything but press the shutter release. When set to TTL, the background tends to be too dark or the subject seems to be unnaturally bright. And remember, setting up your Speedlight for TTL BL flash is easy; after the Speedlight's attached to the camera, turn it on!

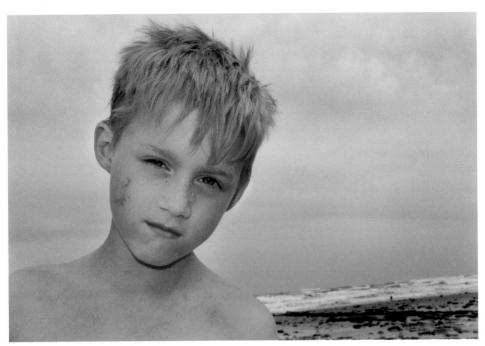

QT.5 An outdoor portrait using TTL BL

Tip

Don't be afraid to use your flash outside in the sun. This is where balanced fill flash excels. The flash fills in some of the harsh shadows that are created by the sun.

Taking photos with the Speedlight on TTL is just as easy as taking photos without a flash. Just press the shutter release. The camera makes all of the adjustments for exposure and adjusts the *flash head zoom* for you.

The flash head zoom is a feature of the Speedlight that adjusts the flash to match the focal length of the lens you're using. Don't be concerned if you don't completely understand how TTL BL works or why the flash zoom is important—you will in good time. By the time you finish this book, you should be an expert. In the meantime, this Quick Tour is just to get you started with flash photography and comfortable with your new flash equipment.

Everything is attached and you have the basic settings, so get out there and shoot. Take some pictures of your friends or significant other. Get your dog or cat posed. Set

up a still life. Experiment with different apertures and shutter speeds. Above all, have fun!

QT.6 A quick snapshot of Clementine taken using the SB-600 with a wide aperture

Using the Creative Lighting System

P A R T

In This Part

Chapter 1 Exploring the CLS

Chapter 2Setting Up the SB-800 and SB-600

Exploring the CLS

he components of the Nikon Creative Lighting System are any Nikon dSLR and the SB-800, SB-600, and SBR-200 Speedlights. Additional components include the SU-800 commander unit, and the R1 and R1C1 macro lighting kits. And, as with any new camera equipment, it is important to know how everything works and where all the controls are.

In this chapter you take a look and the main features and functions of the major components in the Nikon CLS, including the SB-800 and the SB-600. Additionally, this chapter also touches on some features and functions of the SU-800 wireless commander and the SBR-200 macro Speedlight kit. By the end of the chapter, you ought to have an in-depth knowledge of what all the buttons do and how to use the features of the CLS for the best results with your photography.

Features of the Nikon Creative Lighting System

In this section you take a look at all of the available features of the Nikon Creative Lighting System. It's important to keep in mind that although at some level all of these features are available, not all of them are available with certain Speedlight and camera combinations.

While all Nikon dSLR's can be used with the Nikon Creative Lighting System, not all features are available with every camera.

For specific information on what features are available, see the tables in the following pages to determine which features can be utilized with your Speedlight and camera combination.

In This Chapter

SB-800

SB-600

Overview of the SU-800 Commander

Overview of the SBR-200 Speedlight

Components of the Nikon Creative Lighting System

- iTTL. Nikon's most advanced metering system, it uses pre-flashes fired from the Speedlight to determine the proper flash exposure. The pre-flashes are read by a 1005-pixel metering sensor. The information is then combined with the information from matrix metering, which is a reading of how much available light is falling on the subject. The Speedlight uses this information to decide how much flash exposure is needed to create a fill flash.
- Flash Value lock. The FV lock allows you to meter the subject, getting a reading for the proper flash exposure. Pressing and holding the FV lock button allows you to meter the subject, and then recompose the shot while maintaining the proper flash exposure for the subject.
- Advanced Wireless Lighting. This allows you to use your Speedlights wirelessly. The commander unit fires pre-flashes, which transmits information back and forth between the camera and the flash.
- High-Speed Sync. This allows you to use your flash at higher shutter speed than your camera body is rated for. You may want to use this feature when shooting outdoor portraits requiring a wide aperture and high shutter speed.
- Wide-Area AF-assist Illuminator. The SB-800 and SB-600 have a built-in LED that emits a light pattern to give the cameras AF something to lock onto. The LED pattern is wide enough to cover all eleven focus areas on the D200, D2X/s and the D2H/s.

◆ Flash Color Information Communication. As the flash duration gets longer the color temperature changes a bit. The SB-800 and SB-600 transmit this change to the camera body, ensuring a more accurate white balance.

SB-800

The SB-800 has many great features and offers a great deal of versatility when shooting with flash. As you no doubt already have the flash and have read the manual (or at least skimmed through it), you should know the basics about your Speedlight already. But, before you go much further, you should familiarize yourself with the Speedlight.

SB-800 specs and features

This section provides a brief look at different features that are available on the SB-800 Speedlight. It is important to note, however, that some features may not be available to use depending on the camera body you are using. For example, when using the D50 or D70/D70s the FP High Speed Sync feature is unavailable.

The features the SB-800 is capable of include

- Guide Number. 125 at ISO 100 on the 35mm setting. See your owner's manual for more specifics on GNs for specific zoom ranges.
- Automatic zooming flash-head. Provides lens coverage from 24mm up to 105mm, 14mm with the included wide-angle adaptor.

- i-TTL. Supports i-TTL, D-TTL, TTL, and full Manual operation.
- Advanced Wireless Lighting. This allows you to control up to three different groups of Speedlights in TTL, AA, A, or M mode.
- Slow Sync. Enables you to match the ambient background lighting with the flash so the background doesn't end up black.
- Red-eye reduction. Fires off a preflash to contract the pupils to avoid "devil-eyes."
- AF-Assist light. Emits an array of light from an LED to assist in focusing in low-light situations.
- FP High-Speed Sync. Allows you to shoot with a shutter speed higher than the rated sync speed of the camera. This is useful when shooting portraits in bright light using a wide aperture to blur the background.

- Flash Value lock. Using the FV lock you can get a reading from your subject then recompose the shot while retaining the original exposure.
- Distance-priority Manual flash mode. With this mode you put in the distance information and the aperture, the SB-800 adjusts the power level accordingly.
- Modeling flash. Releases a short burst of flashes allowing you to see what the light falling on your subject looks like.
- Repeating Flash mode. Fires off a specified amount of flashes like a strobe light.
- ★ Tilting/rotating flash-head for bouncing flash. Allows you to point the flash-head up for bouncing light from the ceiling or to the side to bounce off of the wall. The SB-800 also allows you to tilt the head downward 7° for close-up subjects.

Understanding the Guide Number

Although the actual power of the flash is fixed, the Guide Number (GN) of the flash changes with the ISO setting of the camera and also varies with the zoom setting of the flash. This is due to the increased sensitivity of the sensor and the actual dispersion of the light when set to a specific zoom range. When the ISO is at a higher setting, the sensor is more sensitive to light, in effect making the flash more powerful, hence a higher GN.

Also, when the zoom is set to a wide-angle, the flash tube is set further back in the flash head, diffusing the light and giving it wider coverage. This makes the flash somewhat less bright, thereby warranting a lower GN.

Remember that the Guide Number is exactly that—a guide. In reality, it is nothing more than a number assigned by the manufacturer to assist you in obtaining the correct exposure. Refer to your owner's manual for a table with the GN of the Speedlight at the specific zoom ranges.

Main parts

The main parts of the SB-800 Speedlight are identified and discussed in the following sections. Figures and explanations of each part and feature are included so you have a clear understanding of how each is used.

▶ Flash head. This is where the flashbulb is located. Inside is a mechanism that zooms the flashbulb back and forth to provide flash coverage for lenses of different focal lengths. The flash head is adjustable; it can be tilted upward to 90° and downward to 7°. It can also be adjusted horizontally 180° to the left or 90° to the right.

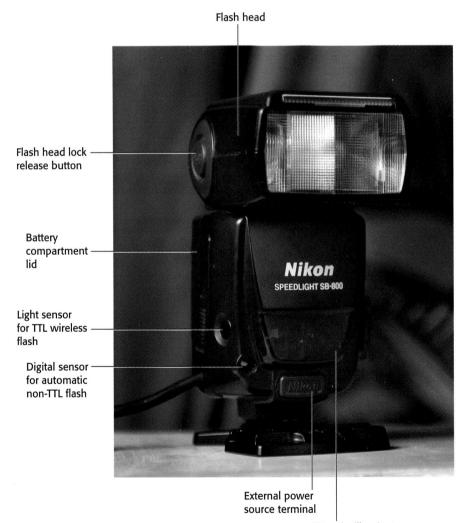

AF assist illuminator

Flash head lock release button. This button releases the flash head lock allowing you to adjust the angle for bounce flash.

Modelingflash

button

Battery compartment lid. Slide this downward to open the battery compartment to change out the batteries.

Flash head tilting angle scale

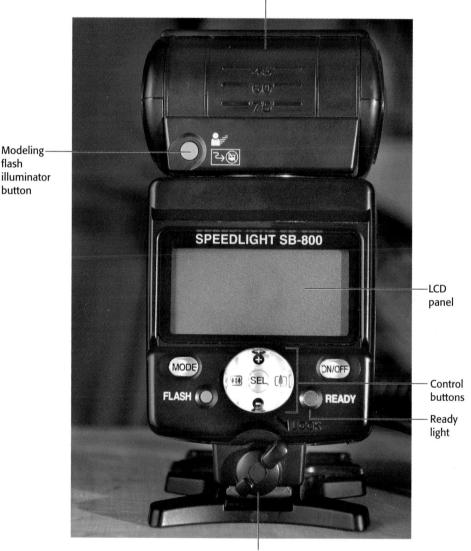

Mounting foot locking lever

14 Part I → Using the Creative Lighting System

- Light sensor for TTL wireless flash. This sensor reads signals from Commander units enabling wireless flash.
- Light sensor for automatic non-TTL flash. This sensor reads the light reflected off of the subject telling the flash when to shut off when operating in AA (aperture automatic mode), or A (non-TTL automatic mode).
- AF-assist illuminator. Emits an LED light array to achieve focus in low-light situations.
- External power source terminal. Nikon's optional external power sources can be plugged in to this terminal, these power sources include the SC-7 DC unit, the SD-8A high performance battery pack, and the SK-6/SK-6A power bracket unit.
- ◆ Flash head tilting angle scale. Allows you to set the flash head at 45°, 60°, 75°, or 90° tilt.
- Modeling flash illuminator button. Fires the flash repeatedly to allow a preview to what the shadows and lighting looks like on the subject.
- LCD panel. This is where all of the Speedlight settings and controls are viewed.
- Control buttons. These are used to set and change setting on the Speedlight.
- Ready light. Lights up indicating the Speedlight is ready to fire. After the Speedlight is fired this light blinks until the Speedlight is fully recycled and ready to fire again.
- Mounting foot locking lever.
 Locks the Speedlight into the hot shoe or the AS-19 Speedlight stand.

Wide-angle lens adaptor. This built-in diffuser provides you with the ability to use the Speedlight with a lens as wide as 14mm without having light fall-off at the edges of the image.

Bounce/ Catchlight card

 Wide-angle lens adapter

- 1.3 Wide-angle lens adaptor and built-in catchlight card
 - Bounce or Catchlight card. This white card reflects light down into the eyes providing a catchlight when the flash is used in the bounced position.
 - **TTL** multiple flash terminal. This is used for linking more than one flash together using TTL metering; requires a Nikon TTL flash cord such as the SC-27. SC-26, SC-19, or SC-18.

1.4 TTL multi-flash terminal (top) and PC sync terminal (bottom)

- PC sync terminal. This is used for linking more than one flash unit in non-TTL mode, usually in manual mode.
- External AF-assist contacts. These contacts are for use with the optional SC-29 TTL remote cord. This allows you to use the AF-assist beam when using your flash off camera.

1.5 External AF-assist contacts and the hot shoe mounting foot

 Hot shoe mounting foot. This slides into the hot shoe on your camera body and locks down with a lever. rotating
angle scale.
This enables
you to rotate
the flash
head horizontally left 30°,
60°, 90°,
120°, 150°,
and 180°. To
the right it
can be
adjusted 30°,
60°, and 90°.

1.6 Flash head rotating angle scale

Control buttons

There are several control buttons on the SB-800 and you should know what each of them does in order to get the best results from your Speedlight. Some of them are obvious, like the On/Off button, but others control the menus you select. You need to know how to navigate your Speedlight.

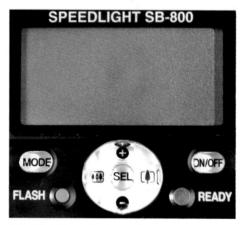

1.7 SB-800 control panel

- Multi-selector button. This main button can be pressed up and down, left and right, or in the center.
 - Up and down. Labeled as + for up and – for down, these buttons allow you to move up and down in the menu, which displays on the LCD when the Speedlight is turned on. Use them to select from the various menu items.
 - Left and right. The left button is labeled with three small trees, symbolizing wide angle. The right button has one large tree, which indicates telephoto. The buttons are used to change the zoom of the flash head for different lens coverage from 24mm wide angle to 105mm telephoto.
 - Select. The center button is the Select button. This button is used to select an item to be highlighted for change after using the up and down buttons to navigate to the item. Press the Select button for two seconds to get to the Custom Settings Mode (CSM). CSM is used to set up specific functions of the SB-800, such as the wireless flash modes, ISO settings, the power zoom function, and many other things.

Cross-Reference

The Custom Settings Menu and the specific functions you can control are covered in detail in Chapter 2.

- The On/Off button. This button does just what it says it does. Press it for about a half a second to turn the Speedlight on or off.
- The Flash button. Press this button to test fire the SB-800 to ensure it is functioning properly or to take a test reading using a hand held flash meter.
- The Mode button. The mode button is used to cycle through the LCD menu among the different flash modes of the SB-800 Speedlight. The different modes are:
 - TTL BL i-TTL balanced fill flash. The exposure is determined by the camera and matched with the ambient light.
 - TTL i-TTL flash. The exposure is determined by the camera to sufficiently illuminate the subject that is focused on.
 - AA Auto Aperture. An aperture-based automatic mode. You enter the aperture value and the Speedlight determines the flash power.
 - GN distance based automatic mode. You enter the distance to the subject and the Speedlight determines the flash power.
 - M full manual mode. You determine the flash power by using the guide number of the flash and dividing this number by the distance of the Speedlight from the subject, with the quotient being the aperture to which you need to set your camera. You can also use a flash meter to determine the flash and camera settings.

Depending on which camera and lens you are using, all of the SB-800 flash modes may or may not be available.

In addition to the standard buttons on the back of the Speedlight, there are some functions that can only be accessed by pressing two buttons at the same time:

- Mode and Select. When these two buttons are pressed in conjunction, the SB-800 shows what the underexposure level was when using the i-TTL flash mode. This is shown as a numeric value on the LCD, such as 1.7 ev.
- Mode and On/Off. Pressing these two buttons simultaneously for two seconds resets all settings to the default factory settings. Refer to your owners manual if you aren't sure what the default settings are.
- On/Off and Select. Pressing these two buttons together locks all of the buttons of the flash to prevent the accidental change of settings. The Flash button and the Modeling Light button are not affected by locking the buttons.

SB-800 accessories

Along with the SS-800 soft case for storing and carrying your SB-800, other important accessories include

- SD-800 quick recycle battery pack. This allows faster recycle time by adding an additional battery.
- AS-19 Speedlight stand. Enables you mount your SB-800 to a stand or tripod, but it also makes it easier to stand the Speedlight on a flat surface.

- SJ-800 colored filter set. The set includes tungsten and fluorescent filters for matching the flash to ambient light, and it also includes red and blue for special effects.
- SW-10H diffusion dome. The dome softens the flash output resulting in more natural looking shadows.

SB-600

The SB-600, while not as feature-rich as the SB-800, still has many features that you will find useful in when shooting with flash. As with the SB-800, you've likely got the flash in hand and have at least skimmed through the manual. At this point, you are probably familiar with the basic features of your Speedlight. The material in the next few sections gives you a better idea of not only what the features are, but also why they are important.

SB-600 feature overview

The SB-600 has less features and a lower Guide Number than the SB-800, but it's still a great flash. Most of the missing features are shooting modes that you may find aren't necessary to have. And, although the GN is lower, the SB-600 is still a powerful flash. Firing the SB-600 at full power using an aperture of f/2.8 it's possible to get a fairly well lit shot at almost two hundred and fifty feet.

This section provides a brief look at different features that are available on the SB-600 Speedlight. It is important to note, however, that some features may not be available to use depending on the camera body you are using. For example, when using the D50 or

D70/s the FP High Speed Sync feature is unavailable.

- Guide Number. 125 at ISO 100 on the 35mm setting. See your owner's manual for more specifics on GNs for specific zoom ranges.
- Automatic zooming flash-head. Provides lens coverage from 24mm up to 105mm. 14mm with the included wide-angle adaptor.
- i-TTL. Supports i-TTL, D-TTL, TTL, and full Manual operation.
- Slow Sync. Enables you to match the ambient background lighting with the flash so the background doesn't end up black.
- Red-eye reduction. Fires off a preflash to contract the pupils to avoid "devil-eyes."
- AF-Assist light. Emits an array of light from an LED to assist in focusing in low-light situations.
- FP High-Speed Sync. Allows you to shoot with a shutter speed higher than the rated sync speed of the camera. This is useful when shooting portraits in bright light using a wide aperture to blur the background. Works with D200, D2X, and D2H camera bodies.
- Modeling flash. Releases a short burst of flashes allowing you to see what the light falling on your subject looks like. Works with D200, D2X, and D2H camera bodies.

 Tilting/rotating flash head for bouncing flash. Allows you to point the flash head up for bouncing light from the ceiling or to the side to bounce off of the wall.

Main parts

Even though the SB-600 Speedlight is similar to the SB-800, it is still important to go over each of the important parts of the equipment. I've included figures and explanations of the parts and features to give you a better understanding of how each is used.

- ◆ Flash head. This is where the flashbulb is located. Inside is a mechanism that zooms the flashbulb back and forth to provide flash coverage for lenses of different focal lengths. The flash head is adjustable; it can be tilted upward to 90°. It can also be adjusted horizontally 180° to the left or 90° to the right.
- Flash head lock release button. This button releases the flash head lock allowing you to adjust the angle for bounce flash.
- Battery compartment lid. Slide this downward to open the battery compartment to change out the batteries.
- Light sensor for TTL wireless flash. This sensor reads signals from Commander units enabling wireless flash.

- Wireless remote ready light.
 Works as a ready light when the SB-600 is being used as a remote flash.
- AF-assist illuminator. Emits an LED light array to achieve focus in low-light situations.
- ◆ Flash head tilting angle scale. Allows you to set the flash head at 45°, 60°, 75°, or 90° tilt.
- LCD panel. This is where all of the Speedlight settings and controls are viewed.

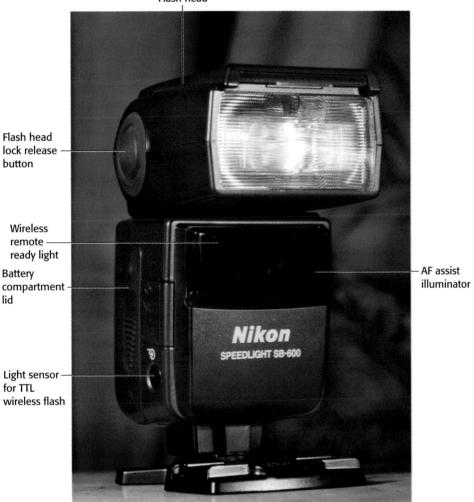

1.8 The front of the SB-600 Speedlight

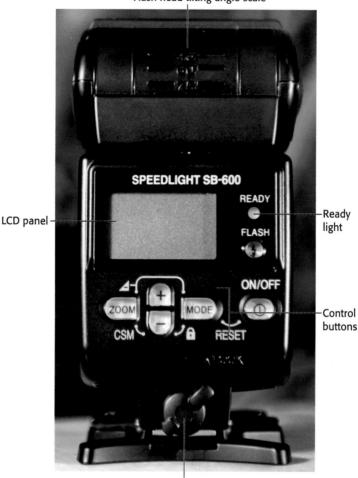

Flash head tilting angle scale

Mounting foot locking lever

- 1.9 The back of the SB-600 Speedlight
- Ready light. Lights up indicating that the Speedlight is ready to fire. After the Speedlight is fired this light blinks until the Speedlight is fully recycled and ready to fire.
- Control buttons. Used to set and change setting on the Speedlight.
- Mounting foot locking lever.
 Locks the Speedlight into the hot shoe or the AS-19 Speedlight stand.
- Wide-angle lens adaptor. This built-in diffuser provides you with the ability to use the Speedlight with a lens as wide as 14mm without having light fall-off at the edges of the image.

1.10 Wide-angle lens adaptor

External AF-assist contacts. These contacts are for use with the optional SC-29 TTL remote cord. This allows you have the AF-assist beam when using your flash off camera.

1.11 External AF-assist contacts and the hot shoe mounting foot

- Hot shoe mounting foot. This slides into the hot shoe on your camera body and locks down with a lever.
 - Flash head rotating angle scale. Enables you to rotate the flash head horizontally left 30°, 60°, 90°, 120°, 150°, and 180°. To the right it can be adjusted 30°, 60°, and 90°.

1.12 Flash head rotating angle scale

Control buttons

You should know what each of the various control buttons on the SB-800 Speedlight can do to get the best results. The following sections describe them.

1.13 SB-600 control panel

- The On/Off button. Press the on/off button for about a halfsecond to turn the SB-600 on or off.
- The Flash button. Press this button to test fire the SB-600 to check for output.
- ★ The Zoom button. Pressing this button changes the zoom of the flash head to adjust for different focal length lenses. It allows coverage for 24mm to 85mm lenses. 14mm coverage is achieved with the built-in wide angle diffuser.
- ★ The +/- buttons. The +/- buttons are used to change the values and settings on the SB-600 LCD screen. Depending on the flash mode the values and settings will be different.
 - TTL/TTL BL. The +/- buttons allow you to set the flash compensation of the Speedlight to underexpose or overexpose from the camera's TTL reading. The flash compensation can be set +/- 3 stops in 1/3 stop increments.
 - M. The +/- buttons are used to set the flash exposure manually from ½ to ¾. These settings are also adjustable in ⅓ stop increments.
 - CSM. When in the custom settings mode, the +/- buttons are used to cycle through the different custom settings.

Cross-Reference

The Custom Settings Menu is covered in detail in Chapter 2 Setting up the SB-800 and SB-600.

- The Mode button. The mode button allows you to switch between the available flash modes. The modes available with the SB-600 are:
 - TTL BL i-TTL balanced fill flash. The exposure is determined by the camera and matched with the ambient light.
 - TTL i-TTL flash. The exposure is determined by the camera to sufficiently illuminate the subject that is focused on.
 - M full manual mode. You determine the flash power.

Depending on which camera and lens you are using, all of the SB-600 flash modes may or may not be available.

In addition to the standard buttons on the back of the SB-600 Speedlight, there are some functions that can only be accessed by pressing two buttons at the same time:

- **▼ Zoom and Mode.** When the Zoom and Mode buttons are pressed simultaneously, the underexposure value from the TTL reading is displayed.
- Mode and On/Off. Pressing Mode and the On/Off button together resets the SB-600 settings to factory default. You may need to do this if you've changed the settings and have forgotten what changes you've made.

Mode and minus. When the mode button and the - button are pressed in conjunction the control buttons are locked to prevent any accidental changes to the settings.

The lock does not affect the flash button and the On/Off button

◆ Zoom and minus. Pressing the Zoom button and the – button together switches to the Speedlight to the Custom Settings Mode (CSM).

The Custom Settings Menu is covered in detail in Chapter 2.

SB-600 accessories

While the SB-600 doesn't have as many accessories as the SB-800, it does still come with the SS-600 soft case for storage and carrying as well as an AS-19 Speedlight stand, which not only allows you mount your SB-800 to a stand or tripod, you can also use it stand the Speedlight on a flat surface.

Other Components of the Creative Lighting System

You have your SB-800 and SB-600 Speedlights, but what else might you need to round out your CLS? These two elements are

a great start, but that isn't all there is to the Nikon Creative Lighting System. However, the components of the Nikon Creative Lighting System are hard to define as a whole. For example, the camera body is an integral part of CLS and, you can use CLS-compatible Speedlights with non-compatible camera bodies, so the line gets a little blurred.

Your D50, D70/D70s, D80, D200, D2H/D2Hs, D2X/D2Xs, or F6 camera body works great with the Speedlights. However, even if your camera is CLS compatible, that doesn't mean it supports every available feature of the Speedlight, as explained in the earlier sections of this chapter. Be that as it may, if you use any of the camera bodies I've mentioned with any of the Speedlights in the following list, you have some, if not all, of the features of Nikon's CLS.

- ♦ SB-800 Speedlight
- SB-600 Speedlight
- SU-800 Wireless Speedlight commander
- SBR-200 Wireless Remote Speedlight
- R1C1 Close-up Speedlight commander kit
- * R1 Close-up Speedlight remote kit

Camera compatibility

Some camera bodies only allow certain features to be used with CLS. Table 1.1 shows which functions are supported by each different camera.

Table 1.1 Nikon CLS Camera Compatibility

Camera Model or Series	CLS Feature	Details
D50	i-TTL flash	Available with the built-in Speedlight, SB-800, and SB-600
	i-TTL balanced fill flash	Available with the built-in Speedlight, SB-800, and SB-600
	Auto aperture	Available only with the SB-800 and an autofocus lens
	Non-TTL Auto	Available with the SB-800
	Distance priority manual	Available with the SB-800
	Wide Area AF-assist illuminator	Available with the SB-800, SU-800 and SB-600
D70/D70s	i-TTL flash	Available with the built-in Speedlight, SB-800, and SB-600
	i-TTL balanced fill flash	Available with the built-in Speedlight, SB-800, and SB-600
	Auto aperture	Available only with the SB-800 and an autofocus lens
	Non-TTL Auto	Available with the SB-800
	Distance-priority manual	Available with the SB-800
	Built-in Speedlight acts as a wireless remote commander	
	Flash Value (FV) lock	
	Wide Area AF-assist illuminator	Available with the SB-800, SU-800 and SB-600
D200	i-TTL flash	Available with the built-in Speedlight, SB-800 and SB-600
	Auto aperture	Available only with the SB-800 and a CPU lens
	i-TTL balanced fill flash	Available with the built-in Speedlight, SB-800 and SB-600
	Non-TTL Auto	Available with the SB-800
	Distance priority manual	Available with the SB-800
	Built-in Speedlight acts as a wireless remote commander	

Camera Model or Series	CLS Feature	Details
	Flash Value (FV) lock	
	Auto FP high-speed sync	Available with the SB-800 and SB-600
	Wide Area AF-assist illuminator	Available with the SB-800, SU-800 and SB-600
D2X/D2Xs and D2H/D2Hs	i-TTL flash	Available with the SB-800 and SB-600
	Auto aperture	Available with the SB-800
	i-TTL balanced fill flash	Available with the SB-800 and SB-600
	Non-TTL Auto	Available with the SB-800
	Distance priority manual	Available with the SB-800
	Flash Value (FV) lock	Available with the SB-800 and SB-600
	Auto FP high-speed sync	Available with the SB-800 and SB-600
	Wide Area AF-assist illuminator	Available with the SB-800, SU-800 and SB-600

Even though each camera doesn't offer full functionality of the CLS features that each Speedlight offers, there are some caveats, as the next sections explain.

D50

With the D50, just because you can't use the built-in Speedlight as a remote commander doesn't mean you can't use advanced wireless lighting. The SB-800 or the SU-800 can be used as the commander for wireless remote Speedlights.

D70/D70s

Although the D70/D70s does allow you to use the built-in Speedlight as a commander, it is somewhat limited. When used as a

commander, the built-in Speedlight does not produce enough light to add to the exposure (this can be good or bad). It allows you to use as many remote Speedlights as you need, but all of the remote units can be used as only one group. Therefore, any exposure compensations you want to make has an effect on all of the Speedlights in the group.

Considering the price of the D70/D70s, this is still an amazing and useful feature. Being able to command even one off-camera Speedlight without the purchase of any additional accessories (other than camera and flash) is a great deal.

There are ways to lessen the exposure of one Speedlight in a group, such as moving it further away from the subject. The other drawback to using the D70/D70s built-in Speedlight as a commander is that it only allows you the option of using one channel. When using the Advanced Wireless Flash different channels can be used to transmit the information to the remote Speedlights. Therefore, in a competitive shooting environment, if someone near you is using the D70 to fire an off-camera flash, their flash will set off yours and vice-versa. As with the D50, when used in conjunction with an SB-800 or SU-800 the full range of advanced wireless lighting options are available including access to multiple channels.

While the D70/D70s do support FV lock, to gain this control you need to access the camera's Custom Settings Menu. In the CSM you can select the AF/AE lock button to act as the FV lock when a Speedlight is attached.

D200

Like the D70, the D200's built-in Speedlight can be used as a wireless remote commander. The D200's built-in Speedlight is a lot more flexible than that of the D70. It allows you to use any number of Speedlights in two groups on four channels. The D200 also allows you the option of using the built-in Speedlight to add to the exposure when acting as a commander.

To achieve the FV lock feature, the D200's function button must be set in the camera's Custom Settings Menu.

The D200 offers the full range of CLS features when used with the SB-800 and a CPU lens, with the added benefit of a built-in wireless commander—something that

the D2-series, which is much more expensive, does not provide. With any camera in the D2 series you have to use either an SU-800 or an SB-800 to use the advanced wireless lighting.

D2X/D2Xs and D2H/D2Hs

You are in luck with the D2 series of cameras when using the SB-600 or SB-800 Speedlights. Not only are they the top of the Nikon camera line, they support all available functions of the SB-600 and SB-800.

SU-800 Commander

A Commander unit is what tells the remote Speedlights when to fire. It also reads the data provided by the remote Speedlights pre-flashes and relays the information to the camera body for use in setting the exposure levels.

The SU-800 is an infrared wireless commander for the Nikon Creative Lighting System. It functions in much the same way as the SB-800 does in Commander mode except that it doesn't emit any visible light. The SU-800 Commander has four independent channels, so if you are working near other photographers you can work on different channels so someone else's SU-800 Commander won't set off your flashes.

It slides into the hot shoe of your camera like any other Speedlight and is used to wirelessly control the SB-800, SB-600, or SBR-200 flashes. Each channel can be used to control up to three groups of flashes. From the SU-800 or SB-800 you can control the output of each group individually. You can set each group to TTL, A, or M in order to fine-tune the lighting to suit your needs.

SBR-200 Speedlight

The SBR-200 is a dedicated macro Speedlight. With macro flash photography it's best to get your flash on axis, or on the same level as the subject. In macro photography, your lens is usually very close to your subject, which ends up blocking the light from an on-camera shoe-mounted flash. This is where lens-mounted flashes come in.

The SBR-200 Speedlight is attachable to your lens via the SX-1 attachment ring. The SX-1 is sold separately from the SBR-200, or you can buy a kit that includes it. Nikon offers two versions of the kit:

- R1C1 kit. This kit includes two SBR-200 Speedlights, an SU-800 Commander, and the SX-1 attachment ring.
- R1 kit. This kit includes two SBR-200 Speedlights and the SX-1 attachment ring.

The SBR-200 can't be mounted to a hot shoe and fired from the camera. It can only be controlled with the SU-800, the SB-800, or by the on-camera Speedlights of the D200 and the D70/D70s.

More macro lighting techniques are covered in Chapter 6.

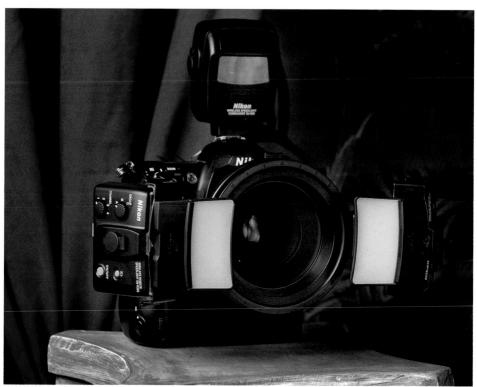

1.14 Nikon D200 with SU-800 commander with two SBR-200 macro Speedlights

Setting Up the SB-600 and SB-800

his chapter covers how to set up your Speedlights for various types of use. I discuss the different flash settings and offer suggestions on when to use them. You also learn how to set up your Speedlights for wireless use and how to set the zoom head for a specific lens.

Power Requirements

The power requirements for the SB-800 and the SB-600 are the same: four AA sized batteries. Having ample batteries for your Speedlight is very important. What's the use in having a wireless portable studio when your batteries die on you? You want to carry at least one extra set of batteries for each Speedlight you have.

If you're going to be using your Speedlights a lot, you may want to check into purchasing rechargeable batteries. The initial investment is a little more than standard alkaline batteries, but you make it back easily when you don't have to pay several dollars for batteries every couple of days. I recommend buying two sets of rechargeable batteries for each Speedlight, which is worth it the long run. You don't want to have to stop in the middle of a shoot to run down to a convenience store to buy second-rate batteries for twice the normal price. Trust me, I've been there. I always have plenty of spare batteries with me now.

Five different types of AA batteries are available for use in Nikon Speedlights that fall into two categories.

In This Chapter

Power requirements

Flash modes

Setting up for the Creative Lighting System

Non-rechargeable

If you are not ready to invest a set or two of rechargeable batteries for your Speedlights, you should consider your choices within the non-rechargeable variety. There are three types to choose from.

- Alkaline-manganese. These are your everyday, standard type of battery, alkaline batteries are available nearly everywhere from your local gas station to high-end camera shops. There can be differences in quality depending on the manufacturer. When buying these types of batteries, I suggest purchasing the batteries that specify they are for use with digital cameras. These batteries usually last longer than the cheaper brands.
- Lithium. Lithium batteries cost a little more than standard alkaline batteries, but they last a lot longer. You can find lithium batteries at specialty battery shops and some camera shops have them in stock.
- Nickel. While these types of batteries are listed in the SB-600 and SB-800 user's manual as being one of the acceptable types of batteries to use, it is very difficult to find them. I have never come across any when looking for them.

Rechargeable

Rechargeable batteries do require more of an initial investment, but you easily get your money back in what you save by not having to buy disposable batteries often. There are two types of rechargeable batteries to choose from for your Speedlights.

- NiCd. Nickel-cadmium batteries are the most common type of rechargeable batteries. You can find NiCd batteries pretty easily. Department stores usually sell them along with a charger for under twenty dollars. Also, you can usually find them at most camera stores. While NiCd batteries are rechargeable, they don't last forever. After time they hold less and less of a charge until they're finally depleted. If the battery is repeatedly charged when it has not been fully exhausted, the life of the NiCd is even shorter. For example, if you come home from a shoot and your battery was only used to half of its capacity, you likely place it in the charger for your shoot tomorrow. After doing that a few times, the battery remembers that it only charges to half power, which is called battery memory. Some manufacturers, however, claim that battery memory does not exist.
- Ni-MH. Nickel Metal Hydride batteries are the most expensive type of batteries, but as the saying goes, "you get what you pay for." AA Ni-MH batteries have two to three times the capacity of AA NiCd batteries, therefore they last longer on a single charge than NiCd batteries do, and the battery memory problem is not as significant. You can find Ni-MH batteries in specialty battery shops.

With Ni-MH batteries, you must fully charge the batteries before you install them into your Speedlight. If one of the batteries in the set becomes discharged before the others, the discharged battery goes into polarity reversal, which means the positive and negative poles become reversed, causing permanent damage to the cells rendering it useless and possibly damaging the Speedlight.

The SB-800's Quick Recycling Battery Pack enables you to use five batteries in order to shorten recycle time between flashes.

Flash Modes

The Nikon Speedlights function with several different flash modes. These modes differ based on which model of Speedlight you're using. The SB-800 has far more options than the SB-600 does. These different modes enable you to customize how your Speedlight reacts to your specific camera settings.

Both Speedlights offer backwards-compatible flash modes for use with non-CLS Nikon digital SLRs and Nikon film cameras. The non-CLS cameras include the D100 and D1 series Digital cameras and film cameras, such as the N80 N90s/F90x, and the F100. These next sections cover which camera operates with which flash mode.

Tip

Pressing the Mode button repeatedly cycles through all of the Flash modes available on that particular camera model.

i-TTL

i-TTL is the newest and most innovative flash mode by Nikon. The camera gets most of the metering information from monitor pre-flashes emitted from the Speedlight. These pre-flashes are emitted almost simultaneously with the main flash so it looks as is the flash has only fired once. The camera also uses data from the lens, such as distance information and f-stop values. i-TTL is available on both the SB-800 and SB-600.

DTTL

DTTL was the first flash metering system for the Nikon digital SLRs. DTTL also relies on monitor pre-flashes and distance information, but was basically a minor improvement on the film-based TTL metering system. The way the system worked, the pre-flashes were read while the shutter was open, making it impossible to relay information to other flash units. The Nikon i-TTL metering is done before the shutter opens enabling it to send information to off-camera units via pulse modulation, which is a series of brief flashes of light that go off in a specific order that transmit information back and forth between the Speedlights. These pulses are emitted so quickly that they are almost undetectable. DTTL is available on both the SB-800 and SB-600.

The early Nikon Digital SLRs use DTTL metering. The D1, D1X, and D100 use the DTTL metering method. Although these cameras can be used with the SB-800 and SB-600, they cannot take advantage of the Nikon CLS. The fact that the SB-800 and SB-600 can be used with this flash mode means that they are backwards compatible.

TTL

The TTL metering system, also known as 3D Multi Sensor metering is Nikon's older film-based flash metering system. The flash exposure is based upon the readings of the monitor pre-flash on a sensor that reads the reflected light off of the film that is loaded into the camera body. The SB-800 and SB-600 also are able to perform 3D Multi Sensor balanced fill-flash, but the calculations for i-TTL BL and the film based TTL BL are wholly different. When the SB-800 and SB-600 are connected to the N80, N90/F90, N90s/F90x, and F100, they perform in this mode. This is another example of the SB-800 and SB-600 being backwards compatible.

Balanced fill flash

Balanced fill (BL) flash mode goes hand in hand with other TTL metering modes. This mode uses the standard i-TTL, DTTL, or TTL readings with readings from monitor preflashes to adjust the flash output to match the level of ambient light. Using the TTL BL mode gives your images a more natural looking feel. Balanced fill flash is available on both the SB-800 and SB-600.

i-TTL, DTTL, TTL all appear as just TTL on the Speedlight LCD. This is due to the fact that, although the Speedlight functions in any of these modes, the camera body only uses one type of metering system. This is also true when using balanced fill flash; the LCD only displays TTL BL.

Manual

Setting the SB-600 or SB-800 Speedlights to full Manual mode requires you to adjust the settings yourself. The best way to figure this out is by using a formula. You need to know the *guide number* (GN) of the Speedlight. The guide number is a measure of the flash output. The higher the guide number the more output and range the flash has. You need to know the GN in order to figure out which aperture to use to get the correct flash exposure for the distance your subject is. The formula to get the correct aperture is: $GN \div Distance = F-stop$.

For more information on how to use this formula in you own photography, see Chapter 3. This formula is covered in depth there

Auto Aperture

In Auto Aperture (AA) mode, the flash output is set based on a monitor pre-flash reading in conjunction with the aperture and ISO settings from the camera. This mode can be used when you want to use a specific aperture.

To use this mode:

- Set the camera to Aperture Priority (A) or Programmed Auto (P) mode.
- Press the mode button on the SB-800 Speedlight until AA appears on the LCD.
- 3. In A mode, look at the flash shooting distance guide on the SB-800's LCD and adjust your f-stop accordingly. When in P mode, the camera automatically sets the f-stop for you.
- Make sure the ready light is on and then take a picture.

Non-TTL Auto flash

When using the Auto flash mode, the monitor pre-flash solely determines the flash output. To adjust the exposure you simply change the aperture value in your camera settings.

To use this mode:

- Set your camera to Aperture Priority (A) or Manual (M).
- Press the Mode button on the SB-800 Speedlight until A appears on the LCD.
- Press the + or buttons to adjust the aperture setting on the flash.
- 4. Set the aperture on your camera to match the setting on the flash.
- 5. Make sure your camera is set to the proper flash sync shutter speed. Your camera does not allow you to set a shutter speed higher than its rated sync speed.
- Check the ready light and then shoot.

Guide number distance priority

The SB-800 controls the flash output according to aperture and subject distance. You manually enter the distance and f-stop value into the Speedlight, and then select the f-stop with the camera. The flash output remains the same if you change the aperture. You can use this mode when you know the distance from the camera to the subject.

To use this mode:

- Set your camera to Aperture Priority (A) or Manual (M).
- Press the Mode button on the SB-800 Speedlight until GN appears on the LCD.
- Press the multi-selector button to highlight the distance display then press the + or - buttons to change the distance range.
- 4. Set the aperture on the camera.
- Check the ready light and then take the picture.

Repeating flash

In this mode, the flash fires repeatedly like a strobe light during a single exposure. You must manually determine the proper flash output using the formula to get the correct aperture (GN \div D = F-stop), and then you decide the frequency and the number of times you want the flash to fire. The slower the shutter speed, the more flashes you are able to capture. For this reason I recommend only using this mode in a low-light situation because the ambient light tends to overexpose the image. Use this mode to create a multiple exposure type image.

To use this mode:

- 1. Set the camera to M.
- 2. Press the Mode button until RPT appears on the LCD.
- Use the SB-800's center Multiselector button to highlight the flash output level and then use the + or - buttons to change the levels.

- 4. Press the center Multi-selector button again. This sets the flash level and highlights the frequency setting. Set the frequency to how many times you want the flash to fire per second.
- 5. Press the center Multi-selector button again. This sets the frequency and highlights the setting for the number of flashes per frame. Set this by pressing the center of the multi-selector again.
- Figure out the proper aperture using the GN ÷ D = Aperture.

For more on using and understanding the $GN \div D = Aperture$ formula, see Chapter 3.

- 7. When the proper exposure is determined, make sure the aperture setting on the flash and camera are the same. If they aren't set the same, the exposure won't be correct.
- 8. Set your shutter speed. Your shutter speed depends on the frequency of the flash and the repeat rate. You figure this out by doing a little math. Your shutter speed is equal to the number of flashes per frame divided by the frequency. Sound confusing? It's really not. Say you set the frequency to 5 Hz, and you want the flash to fire 20 times in a single frame, you divide 20 by 5. So you need a 4-second shutter speed.
- Check the ready light and then shoot the photo.

Any overlapping images will be overexposed if the flash exposure is correct. To prevent this, underexpose the image by reducing the aperture by one stop.

Setting Up for the Creative Lighting System

This part is where you get into the tech stuff: How to set up your Speedlight as a wireless remote flash (slave); how to adjust the exposure to suit your needs; setting up groups of lights; and so on. You are no doubt beginning to see just how versatile and powerful a tool the CLS can be. The only limit is your imagination.

You can control an infinite amount of flashes (if you can afford to buy them) all from your camera. You don't even need to have a light meter, the camera meters for you. If you don't like the way the light looks, you can change it without having to walk across the room to a power pack. This is all very convenient.

Commander

The first thing you need to do when setting out to use the CLS wirelessly is set up a commander unit also known as a *master flash*. The master flash is what controls all of the wireless slaves and tells them what to do. The master can be an SB-800, SU-800, or the built-in Speedlight on your D70/D70s, D80, or D200 camera.

For information on setting up a commander unit see Chapter 4

Wireless remote flash

The wireless remote flash is main advantage of CLS. It's all about getting the flash off of your camera. By doing this, you are able to control the light in a much better way. You don't have to have full frontal light. You can

place an SB-600 off to the side in order to accent your models features better or place an SB-800 above an object to highlight the texture. The possibilities are endless.

The Speedlight's wireless remote function is set in the Speedlight's Custom Settings Menu.

SB-600

To set up the SB-600 for use as a wireless remote flash:

- Go into the Custom Settings Menu (CSM) on the Speedlight. Press the Zoom and – buttons simultaneously for about two seconds to get there.
- Cycle through the CSM using the + or - button until you see a squiggly arrow that says OFF above it.
- Press the Zoom or Mode buttons to turn the remote setting on. You also use this same method to turn the remote setting off.
- Press the On/Off button. This brings you to the wireless remote settings menu.
- Press the Zoom button to set the flash zoom to match the focal length of the lens you're using.
- 6. Press the Mode button to select the channel. When the channel is ready to be changed, it flashes. Use the + or – buttons to change it.
- 7. Press the Mode button again.
 This sets the channel and moves you to the Group setting.

8. Press the Mode button again to set the Group setting. The group letter flashes when ready to be changed. Use the + or – to change the setting.

To return the SB-600 to default settings press the Mode and On/Off buttons simultaneously for two seconds.

SB-800

To set up the SB-800 for use as a wireless remote flash:

- 1. Go into the CSM on the Speedlight. Press the Select (SEL) button for two seconds to get there.
- Use the + or and the left and right Zoom buttons to choose the wireless settings menu. The menu has the icon of a flash with an arrow next to it.
- Use the + or button to select REMOTE from the menu.
- 4. After you're in the Remote mode, press the Select button (SEL) to highlight the channel number. Use the + or – buttons to select the proper channel.
- 5. Press the Select button (SEL) again to set the channel and highlight the Group settings. Select the Group you want the flash used with: A, B, or C.

To return the SB-800 to default settings press the Mode and On/Off buttons simultaneously for two seconds.

Sound

When the SB-600 or SB-800 Speedlights are used as wireless remotes, by default they are set to beep when the flash has recycled. This sound is to let you know that flash is ready to fire again. You can turn this setting off if you're using multiple flashes or if you just don't want to hear it. If you're using three or four Speedlights, this can cause quite a racket.

SB-600

To turn the sound function of the SB-600 on or off:

- Go into the CSM. Press and hold the Zoom and – buttons at the same time for two seconds to get there.
- Turn the wireless remote feature on. See the previous set of steps for the SB-600 for details on how to do this.
- Use the + or buttons to select the sound function. The sound function menu has a musical note and says On or Off depending on the setting. The default is On.
- 4. Press the Zoom or Mode button to turn it on or off.
- Press the On/Off button to return to the wireless remote default menu.

SB-800

To turn the sound function of the SB-800 on or off:

 Go into the CSM. Press the SEL button for two seconds to get there.

- Use the + or and the left and right Zoom buttons to choose the wireless settings menu. The menu has the icon of a flash with an arrow next to it.
- Use the left or right buttons of the multi-selector to highlight the sound icon. The sound icon looks like a musical note.
- Press the + or button to turn the sound on and off.
- Press the SEL button to return to the wireless remote menu.

Zoom position

The zoom position focuses the light from the flash in order to match the angle of coverage of your lens. The coverage for wideangle lenses needs to be wider so the flash head is zoomed back, diffusing the light and allowing it to disperse in a wider area. When a longer lens is used, the light output is focused to allow a further distance to be achieved.

By default the SB-600 and SB-800 automatically set the zoom to match the lens. I recommend leaving it on the default setting.

When the Speedlight is used as an off camera wireless remote, the Auto Zoom function is disabled and the flash head zoom has to be set manually.

SB-600

To set the zoom manually:

 Go into the CSM. Press and hold the Zoom and – buttons at the same time for two seconds to get there.

- Use the + or buttons to enter the Zoom menu. The default menu will indicate manual zoom is off.
- Use the Mode button to turn the manual zoom on.
- Press the On/Off button to return to main menu.
- Use the Zoom button to choose the correct zoom position.

SB-800

To set the zoom manually:

- Press the SEL button for two seconds to enter the CSM.
- Use the + or and Zoom buttons on the Multi-selector button to enter the Zoom menu.
- 3. Use the + or buttons to turn the auto zoom off.
- Press the on/off button to return to the main menu.
- 5. Use the Zoom buttons on the Multi-selector buttons to change the zoom range. The Zoom buttons have tree icons on them. The button with three trees is for wide angle lenses and the button with one tree is for telephoto lenses.

Channels

When using a Speedlight in the wireless mode, you can choose on which channel your commander unit communicates with the remote. You have four channels from which to choose. This feature is included because sometimes professionals can be shooting where other photographers are using the same equipment. In order to

prevent another photographer's Speedlights from setting off your own (and vice-versa), you can set your remote commander to a different channel.

Channel settings are changed in the Speedlight Custom Settings Menu, which was explained earlier in this chapter.

The SU-800, SB-800, and the built-in Speedlight on the D200 can all be set to four different channels. The built-in flash on the D70/s functions as a commander only if the remote flash is set to Channel 3 Group A. In other words, you can't change the channel on the D70/s built-in Speedlight.

Setting groups

When using more than one Speedlight, you want to set up your Speedlights in separate groups in order to adjust the lighting for each group to different levels. Setting each group to different levels enables you to achieve three-dimensional lighting. When all of the Speedlights are set the same, the lighting will be flat and even. For some subiects this is good, but for other subjects you want vary the light output in order to show texture and contour. For example, when shooting an object such as a circuit board, you want the lighting to be nice and even so you can see all of the details with clarity. On the other hand, when photographing a portrait, you want to show depth and have a varied tonality, so you want your main light to be brighter than your secondary fill light. To achieve this, you adjust your fill light so that the output is less than the main light. When the Speedlights are set to different groups, you can adjust one without making changes to the other.

Adjusting output compensation – on camera

As I discussed previously, you don't always want your Speedlights firing at the same output. Your camera and Speedlight take a reading to decide how much output is needed for a perfectly lit exposure. Your camera's idea of a perfect exposure doesn't take into account your artistic vision. This is where you decide how you want your image to look.

Adjusting the output can be done in a number of different ways. When the Speedlight is mounted on camera, you can adjust the output on the camera body itself. Most

Nikon dSLRs have a Flash button for setting red-eye reduction, rear curtain sync, and slow sync. Pressing this button and using the front Command dial lets you adjust exposure compensation.

You can also adjust the flash output on the Speedlight. When the SB-600 is attached to your camera body in TTL mode, simply press the + or – buttons to increase or decrease the exposure accordingly.

To change exposure compensation on the SB-800 in TTL mode, press the SEL button to highlight exposure compensation value, then use the + or – buttons to make the adjustments. When your adjustments have been made, press the SEL button again to return to the default menu.

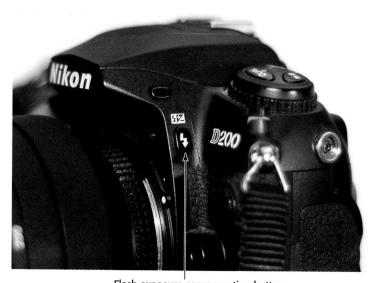

Flash exposure compensation button
2.1 Flash exposure compensation button on the D200 camera body

Adjusting output compensation – wireless mode

When using the Speedlight as a wireless remote, adjusting the output varies depending on what you're using as a commander unit. The D70/D70s and D200 built-in Speedlights can be used as commanders, while the D2 series require an SU-800 or SB-800. The D50 built-in flash doesn't support wireless flash, so it also needs an SB-800. For that reason, I only discuss the D70/D70s and D200 cameras, as the others are covered by the SB-800.

The SB-600 cannot be used as a commander unit.

D70/D70s

When using the D70/D70s built-in flash as a commander unit, to adjust the exposure compensation you have two choices: you

can set the built-in flash to commander Manual and adjust the output from the camera flash menu, or you can set the built-in flash to commander TTL and adjust the output by pressing the Flash button and using the front Command dial to add or reduce exposure. The Flash button is located on the left side of the camera (with the lens facing away from you) just below the built-in flash and if front of the Exposure Mode dial.

Note

The D70/D70s built-in flash doesn't allow more than one group to be used, so when using multiple Speedlights in wireless mode using the D70/D70s as a commander, the exposure adjustments affect all Speedlights. The only way to adjust the Speedlights individually is to move the flash closer for more exposure or further away for less exposure.

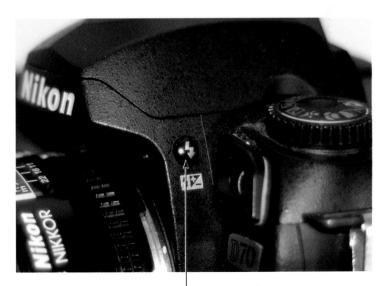

Flash exposure compensation button

2.2 Flash exposure compensation button on the D70 camera body

D200

Using the D200 built-in flash as a commander, the exposure compensation is controlled within the Commander Mode menu. In this menu, you choose the group and make the changes with the camera. The menu enables you to adjust the exposure of the built-in Speedlight, and Groups A and B individually.

You can also make changes globally by pressing the Flash button on the camera body and using the front command dial. When using this method, the change is applied to all groups including the built-in Speedlight.

SB-800

First you must set the SB-800 to act as a master flash in the CSM. When in the Master

Flash menu, use the SEL button to cycle between groups. After you have the proper group highlighted, use the + or – buttons to adjust the exposure up and down.

SU-800

To adjust flash exposure using the SU-800 as a commander, first use the toggle switch to set the SU-800 in Commander mode. The switch is located next to the battery compartment. The toggle switch changes between close-up and commander functions. Press the SEL button to select the Flash mode. After the Flash mode is selected, press the Mode button. Press the Select button again to highlight the exposure compensation for each group. Use the left and right arrows to increase or decrease exposure.

2.3 The SU-800 on camera

Locking controls

After you have the settings on your Speedlight where you want them, you can lock the settings in to prevent accidental changes from occurring while you handle the flash units. This function ensures that your Speedlights stay exactly as you set them.

Although the settings are locked, some buttons not affecting settings still function normally. On the SB-600, the lock does not affect the On/Off button and the Flash Test button. On the SB-800, the On/Off button, the modeling illuminator, and the Flash Test button are not affected.

SB-800

To lock the settings on the SB-800, simply press the On/Off and SEL buttons at the same time for two seconds. To unlock the settings repeat the procedure.

SB-600

To lock the settings on the SB-600, press the Mode and – buttons simultaneously for two seconds. To unlock, repeat the procedure.

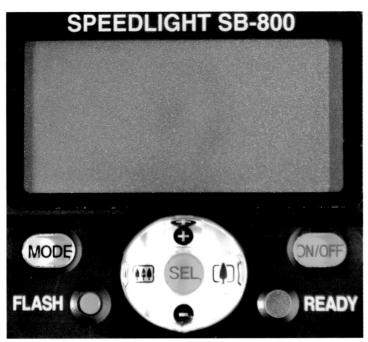

2.4 Press the two buttons highlighted in green for two seconds to lock the SB-800's settings.

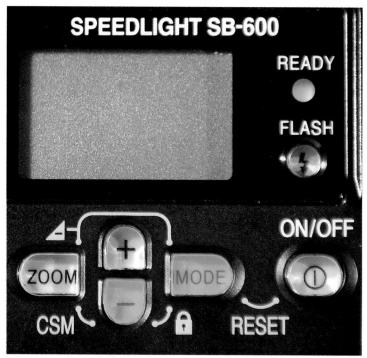

2.5 Press the two buttons highlighted in green for two seconds to lock the SB-600's settings.

Red-eye reduction

Red-eye. . . everybody's seen it in a picture at one time or another. The devilish red glare makes your subjects look like they crawled out of the ninth ring of Dante's Inferno. This anomaly is fortunately not caused by demonic possession, but is caused by the reflection of the light from

the flash off of the eye's retina (back of the eye). Most cameras that have flash compatibility have a red-eye reduction function, which consists of a pre-flash or an LED that produces a light bright enough to constrict the pupils, therefore reducing the amount of light reflecting entering the eye and bouncing off of the retina.

Red-eye reduction cannot be set on the SB-800 or SB-600. The camera body controls this function. Most, if not all Nikon dSLR camera bodies have some sort of red-eye

reduction function. Consult your specific camera's owners manual for instructions on how to set it up.

2.6 Without red-eye reduction

2.7 With red-eye reduction

AF Assist

When photographing in a dark environment, it is sometimes hard for your camera's autofocus sensor to find something to lock on to. When using an SB-800 or SB-600 in a low-light situation, the flash emits an LED pattern to give your camera sensor something to focus on. For this feature to work, you must be using an AF lens and the camera's focus mode must be set to Single focus.

The AF Assist function can be turned on and off in the CSM. By default it is on and I recommend leaving it that way.

SB-600

Turning the AF-ILL on and off on the SB-600:

- Press the Zoom and buttons for two seconds to enter the CSM.
- Use the + and buttons to select the AF-ILL menu.
- Use either the Zoom or Mode button to turn the AF-ILL on or off.
- Press the On/Off button to return to the main menu.

SB-800

To turn the AF Assist illuminator on and off on the SB-800:

- 1. Enter the CSM by pressing the SEL button for two seconds.
- Use the + or buttons and the left and right Zoom buttons to choose the AF-ILL menu, and then press the Select button.
- Use the + or buttons to turn the AF-ILL on or off.
- Press the On/Off button to return to the main menu.

LCD panel illumination

The LCD panels of both the SB-600 and SB-800 have a light built-in to help viewing in low-light situations. By default this is set so that when you press any button on the SB-600 or SB-800, the illuminator turns on and remains lit for sixteen seconds. You can turn this function off in the CSM.

I usually keep mine turned off, as LCD lights use up a lot of battery power.

Even when the LCD illuminator is set to off in the CSM, the LCD panel lights up when the flash is attached to a camera and the camera's LCD panel illuminator is turned on.

Standby mode

Both the SB-800 and SB-600 have a standby mode. The standby mode puts the flash to sleep when not in use. This function helps conserve battery power. When the Speedlight goes in to standby, all you need to do to wake it up is to press any button on the camera body or any button on the Speedlight itself. When the Speedlight is in standby mode the Speedlight's LCD displays STBY.

The Speedlight defaults have the standby set to automatic. I leave my Speedlights at this setting because it saves battery power and when the flash goes to sleep it only takes a fraction of a second to wake it up again. Of course, you can turn the standby function off by selecting it in the CSM.

When the Speedlight is in wireless remote mode it will not go into standby.

Creating Great Photos with the Creative Lighting System

PART

Ш

In This Part

Chapter 3Flash Photography Basics

Chapter 4
Wireless Flash
Photography with the
CLS

Chapter 5Setting Up a Wireless
Studio

Chapter 6Real-World
Applications

Chapter 7Simple Posing for Great Portraits

Flash Photography Basics

his chapter goes over some of the basic information you should know when starting out with flash photography. For those of you who aren't new to using external flash or the CLS, much of this may be a review—but you might learn a thing or two about your Speedlights and how to best use them. If you are new to the CLS then this chapter is a great resource for you and a great reference tool as you experiment and practice with your new Speedlight or Speedlights.

Speedlights versus Studio Strobes

There are many reasons why you'd want to use Speedlights instead of studio strobes. That being said, there are also many reasons to use studio strobes. Each type of light has its own strong points. When deciding what type of lighting to get you really need to look at what you'll be using it for.

If you know you are traveling with your lighting setup, the portability of the Speedlights comes in handy. If you have a studio and you need a lot of light for big subjects, studio strobes may be the way to go.

This isn't to say you need one or the other. Most professional photographers use both. I own both studio strobes and Speedlights. When I go out to shoot on location, you can bet that I don't drag out those heavy old Speedotrons.

In This Chapter

Basics of lighting

Color temperature and white balance

Using bounce flash

Using close up and macro flash

Explaining flash exposure This section discusses the pros and cons of the different lighting systems.

- Portability. Let's face it, you can pack three or four Speedlights in one bag, which only weighs a few pounds. You still need stands and umbrellas for many types of shooting, but Speedlights are small and very portable.
- ▶ Power. Speedlights run on AA batteries. You don't have to rely on household current and long extension cords to power these flashes. You can power studio strobes with accessory batteries, but they weigh more than the strobes themselves in some cases. That's one more piece of equipment, per strobe, that you have to worry about.
- Tip When first setting up for a studio session, I always put a set of freshly charged set batteries in each Speedlight I use. I find that one set of batteries can last me for hundreds of photos, often lasting me the entire job. It's a good idea to buy at least one set of extra batteries for each Speedlight you own.
- Ease of use. After you arrange and configure your Speedlights, you're ready to shoot, controlling flash output centrally. With studio strobes, you have to add yet more equipment to achieve the same advantage.

3.1 I use an old camera bag to carry all my Speedlights and accessories.

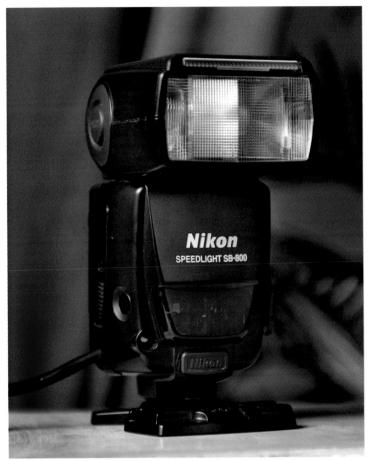

3.2 The SB-800 is all you need to control lighting output from multiple Speedlights.

▶ TTL. With studio strobes, you don't have the advantage of through-the-lens metering. When using the Nikon version of TTL (i-TTL), the camera automatically adjusts the exposure according to the desired flash output and adjusts distance to the subject as calculated from the lens distance setting. This automatic adjustment is a huge advantage of using Speedlights — you can just

basically set up your Speedlights for i-TTL set the groups and channels, and start shooting. Your Nikon camera does the rest. With studio flashes, you have to set up the output for each flash manually.

Cross-Reference

For information on setting groups and channels see Chapter 2.

I'm not one to advocate that using Nikon Speedlights is the only way to go for studio lighting, but it's a great start if you're either on a budget or need the advantage of portability. Studio strobes do in fact offer a few advantages over using Speedlights in some studio lighting situations. Here are a few:

- Power. Studio strobes often offer the photographer more flash power and more light with which to work. In other words, you can illuminate your subjects from greater ranges (Speedlights are limited to less than 100 feet). Many studio strobe models easily provide more light output, which is an advantage if your studio work consists of illuminating large objects (such as automobiles), or even large group portraits. Additionally, you won't have to change batteries every 150 flashes as you do when using Speedlights.
- Recycling time. Recycling time is the amount of time it takes the flash to be ready for another photo. Speedlights typically take .1 to 6 seconds between shots, where studio strobes can fire multiple bursts in that same timeframe.
- Availability of accessories.

 Studio strobes offer a much wider range of light directional accessories. Barn doors, snoots, softboxes, umbrellas, gels, and diffusers are standard studio strobe accessories. Although most of these accessories are available for Speedlights, they are not widely available, and you may have to special order them. Photographers often rely on mixing and matching these accessories to gain more lighting effects for their work.

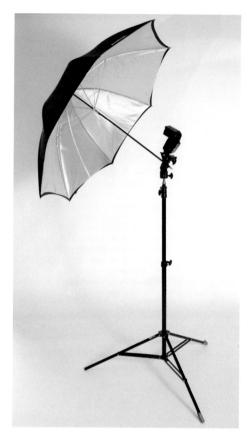

3.3 An example of a light modifier – SB-600 with an umbrella attached for diffusion.

Modeling lights. Studio strobes have the ability to illuminate the subject before the flash is fired using a modeling light. A modeling light is a second light element in the strobe head that when turned on, simulates the light output of the flash, allowing the photographer to pre-adjust the lighting to his/her taste. Although the SB-800 has a modeling light feature, the modeling light isn't continuous so as to allow you to preview the effect at all times.

The modeling light from a Speedlight fires a quick 2.5 second series of flashes. It doesn't provide constant lighting so you can see what you are doing. It also eats your battery power quickly.

Even though studio lighting in a more traditional sense does have some advantages over using Speedlights, the ease of use and capability of Speedlights is very appealing to many photographers who normally wouldn't bother with studio strobes. For small studios or when in need of portability, using multiple Speedlights is still a very attractive alternative to traditional studio strobes.

Basics of Lighting

When working with Speedlights, the first attribute you think of is strictly studio and portrait photography. The truth is, using Speedlights can span other types of photographic conditions and can be used to enhance other types of lighting in those situations. Think of the subjects you would normally shoot in a studio: people, pets, still life, and products. In those situations, you can use a mixture of natural light (possibly from a window or skylight) and flash. When using the outdoors as your studio, you can shoot many different types of portraits, still life, and product photos, but you have different lighting options from which to choose. Regardless if you're shooting indoors in your home, a formal studio, or outdoors, using Speedlights have their place in each type.

Additional information on using Speedlights for the specific scenarios within the various categories of photography can be found in Chapter 6.

Having the capability of using multiple Nikon Speedlights wirelessly as your main lighting system is great. It's even more beneficial when you understand how using Speedlights can enhance your photography in almost any environment. The last thing you want to do is have all the great equipment available to you without understanding how to apply the gear to your photography. First, consider the different types of studio or outdoor lighting options you can create.

Studio lighting

Whether you're setting up a dedicated space for an elaborate studio for your indoor photography or you're using a temporary setup in your living room, studio lighting concepts are the same. If you're just starting out experimenting with studio lighting, your living room, basement, or garage will do just fine. The most important factor to remember with studio lighting is that you control the light with which you illuminate your subjects; you don't let the light control you.

Placement

When taking photos in a studio, first you need to plan how you want to light your subject. This is where your creativity comes into play. Envision how you want your image to appear and then arrange your lighting accordingly. When planning your photographs, take these concepts into account:

- ◆ Visual Impact. Photographers take a lot of portraits and still life images in their everyday work, but the best images contain a combination of a strong subject matter and creative lighting. When setting up your studio photos, take color, tone, and lighting all in consideration when creating your image, as shown in the image in figure 3.4. With a little planning, you can maximize the visual impact of your image.
- ▶ Direction. When setting up the lighting of a subject, the direction of the lighting is your key to success. There isn't any rule for the proper direction of the light from your Speedlights. That decision is up to you and how you want your subject to appear in the final image. When shooting portraits or a still life, plan the direction of your main light. You can keep your main light straight on the subject, move it to the left or right, or even place it behind the subject.

3.4 Plan your studio setup for visual impact, taking color, tone, and lighting into consideration.

Amount: You may have heard the terms high key or low key lighting. Simply put, high key lighting is bright and evenly lit, usually having a bright background and a low light ratio of approximately 2:1. Conversely, low-key lighting is dramatic lighting, often featuring dark, shadowy areas and ratios of at least 3:1 or higher.

3.5 Example of a low-key image.

3.6 The amount of light can drastically change the mood in an image. This is an example of a high-key image.

Tip

You don't have to have three or four Speedlights to set up a studio. Many photographers, even professionals, capture great portraits using one flash, either on or off the camera. If you're using just one Speedlight, consider investing in the Nikon SC-29 off camera hot shoe cord. Moving the Speedlight offcamera results in better control over lighting angle, and connecting the Speedlight with this accessory still gives you all the flash-to-camera communication capabilities.

Basic Portrait lighting types

Two basic types of studio lighting for portraits are *broad* and *short* lighting. If you're a frequent reader of lighting and photography books, you'll also hear the terms *wide* or *short* lighting. Either way, the two pairs of terms mean the same thing.

Broad or wide lighting refers to a key (main) light illuminating the side of your subject as they are turned toward the camera (see figure 3.7). Short lighting, used more frequently, is a key light used to illuminate the side of the subject turned away from the camera (figure 3.8), thus emphasizing facial contours. When using multiple lights, using a fill flash (at a lower power) in conjunction with a key light is common practice.

You may not always be taking portraits in your studio, but that doesn't mean that broad and short lighting techniques do not apply. When shooting portraits outdoors using the sun as your main light and the Speedlight as a fill, the same rules apply. When the sun is lighting the side of the model facing you, you have broad lighting. When the sun is lighting the side of the model away from you, you have short lighting.

Other types of lighting include:

- Diffused lighting. Light emitted from a Speedlight can be considered harsh, especially for portraits where the flash is used in close proximity to the subject. Harsh light is strong, with a lot of contrast, and when used for portraits, brings out the worst in skin tones. Harsh light can be too accurate! When taking portraits, bouncing your Speedlight through or from a transparent umbrella or using a diffusion dome over your flash head can help soften the lighting in a portrait, as shown in figures 3.9 and 3.10.
- Frontal lighting. This type of lighting is a low key technique to achieve dramatic portraits. The lighting is very soft in nature, where the main light often comes from a single Speedlight attached to the camera.
- Mixing ambient or natural lighting. You are often faced with mixing the available light in a scene, whether from existing indoor lighting (ambient) or natural lighting (from a window). You may even want to preserve the tone of the existing light, and only use a flash to match the metered reading of the room for enhanced lighting.
- ▶ Bounced lighting. For excellent snapshots on-the-go, point your flash head at a 45-degree angle toward the ceiling. You get a result of an evenly lit subject with a soft, subdued lighting. I often use bounce flash for photojournalistic images I take during weddings or for just snapshots of friends and family. I explain more about bounced lighting later in this chapter.

3.7 Broad lighting illuminates the side of the subject that is turned toward the camera.

 $3.8\,$ Short lighting illuminates the side of the subject that is turned away from the camera.

Lighting Ratios

Lighting ratios are the difference in light intensity between the shadow and highlight sides of your subject. Lighting ratios are expressed as any other ratio is, for example, 2:1, which translates as one side being twice as bright as the other. You use ratios when you want to plan how much contrast you want in a portrait or still life. Lighting ratios determine the amount of shadow detail in your images. You can get very accurate measurements for lighting ratios using Speedlights in i-TTL mode. Adjusting ratios are achieved by making adjustments on the master unit for each flash. Here, the figure shows a portrait taken with a 3:1 lighting ratio.

3.9 Direct flash can result in harsh results, especially for portraits. Note the shadow behind the model.

3.10 Diffused flash can result in a softer, much smoother lighting for portraits.

Using Speedlights outdoors

One of the most important tools you can have for taking outdoor portraits is a Speedlight. The best light to use is what nature provides, but when taking photos of people or pets outdoors, I almost always use a Speedlight as a *fill flash*. Fill flash is using the flash, not as your main source of lighting, but as a secondary source to fill in the shadows, resulting in an image with less contrast between the shadows and the highlights.

Light diffusers or reflectors are important tools to use for outdoor portraits, or macro shots, but using a Speedlight outdoors for those shooting situations is just as, if not, more important. Advantages of using Speedlights when taking shots outdoors include:

◆ Creating a fill light. Using a Speedlight when taking portraits outdoors enables you to create a properly lighted portrait where the subject is lighted and exposed correctly, giving a more professional looking effect as seen by comparing the images in figure 3.11 and figure 3-12. Using a fill light can be the difference between having your image appear as a snapshot instead of a professional looking portrait.

- Reducing contrast. A Speedlight can improve an outdoor portrait in high contrast situations. Using a Speedlight can help reduce the difference between the shadows and the highlights.
- Providing light in the dark. Don't limit yourself to outdoor shooting only in the daytime. When using Speedlights, you can take photos outdoors even at night, as shown in the photo in figure 3.11.

3.11 You can achieve dramatic images even at night by using a Speedlight.

Color Temperature and White Balance

Light, whether it be sunlight, moonlight, florescent light, or light from a Speedlight, is measured using the Kelvin scale. This measurement is also known as *color temperature*. One of the advantages of using a digital camera is the ability to measure the color temperature of light through the lens. If your Nikon digital camera is set to an automatic light balance, then it automatically adjusts the white balance for the shot you are taking. The result of using a correct white balance setting with your digital camera is correct color in your photographs.

What is Kelvin?

Kelvin is a temperature scale, normally used in the fields of physics and astronomy, where absolute zero (0° K) denotes the absence of all heat energy.

Kelvin and color temperature is a tricky concept as it is opposite of what we generally think of as "warm" and "cool" colors. On the Kelvin scale, red is the lowest temperature increasing through orange, yellow, white, and shades of blue are the highest temperatures. Humans tend to perceive reds, oranges, and yellows as warmer and white and bluish colors to be cold. However, phys-

ically speaking the opposite is true as defined by the Kelvin scale.

To make this even more confusing, when you set the white balance on your camera using the Kelvin scale, the higher the temperature you select, the redder the image is. What you need to remember is that when you are setting the white balance on your camera, what the camera is actually doing is filtering out the color of the light that matches the color of the temperature in Kelvin scale.

Preset white balance

Most digital cameras, especially digital SLRs, let you choose the white balance setting manually and even set custom white balance settings. However, for the most part, automatic white balance settings work well in most situations. The next series of images shows the difference in white balance settings from a photo shot with multiple Nikon SB-800s. Each photo represents a different white balance setting, with color temperatures ranging from 2800K to 7500K. The lower the color temperature, the more blue appears in the image. The higher the color temperature, the more red and yellow appear in the image.

Don't always rely on the automatic white balance settings, especially in mixed light or other difficult lighting situations.

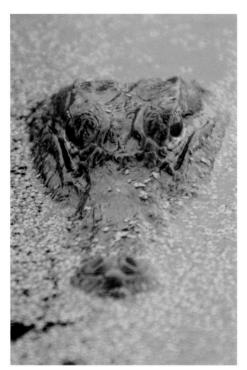

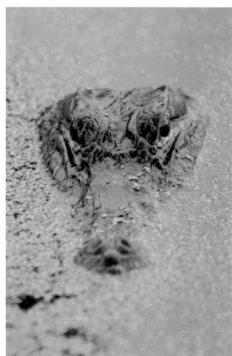

3.12 Tungsten, 2800K

3.13 Fluorescent, 3800K

3.14 Auto, 4300K

3.15 Flash, 5500K

3.17 Cloudy, 6500K

Consider these facts regarding white balance and using Speedlights:

- Speedlights are set to 5500K. Speedlights produce light with a color temperature of 5500K, which is also the same color temperature as the daylight white balance setting on Nikon dSLRs. When shooting subjects with Speedlights, set the white balance setting on your digital camera to the Flash setting.
- Cooler color temperatures appear blue. If your digital camera is set to a white balance setting that represents lower color temperatures (below 5000K), your images appear more blue, or cooler.
- Warmer color temperatures appear yellow. Setting your digital camera to a white balance setting

that represents higher color temperatures (above 5000K) makes your images appear more yellow. These images are considered to appear warmer.

Automatic white balance settings can be very accurate.

Today's digital cameras perform a very accurate job of measuring a subject's white balance. Setting your digital camera to an automatic white balance setting often results in a correctly color temperature balanced image. When using Auto white balance and a Speedlight with a CLS-compatible digital camera, the Speedlight sends color temperature information to the camera usually resulting in a more accurate white balance than when set to flash white balance.

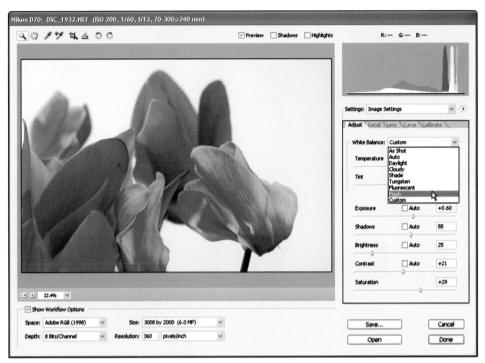

3.18 Using Camera Raw to adjust the white balance of an image on your computer

Tip

By keeping your digital camera set to the automatic setting, you reduce the amount of images taken with incorrect color temperatures. Most of your images, in many lighting situations (with or without the use of Speedlights) are very accurate. You may discover that your camera's ability to evaluate the correct white balance is more accurate than setting white balance settings manually.

Shoot in RAW format for ultimate control of white balance.

All Nikon digital SLRs models offer you the ability to shoot your images in RAW mode. When shooting your images in RAW format (instead of JPEG or TIFF), you have the ability to adjust the white balance of your images after you transfer the files to your computer. By using the RAW conversion software that was included with your digital camera or using Adobe Camera Raw (included with Photoshop CS, CS2, and Photoshop Elements), you can actually adjust the white balance of an image after you take the shot.

Using Bounce Flash

When shooting photos with a Speedlight attached to your camera, you can achieve dramatically different lighting effects by bouncing the light from your flash off the ceiling (or reflector) onto your subject. Bounce flash provides a softer and more evenly lit image.

Bounced flash is a technique used indoors in most situations and can be accomplished a couple of different ways. Most commonly, your flash head needs to be positioned so the light is focused on the ceiling or wall, thus bouncing the light on your subject. Another technique that enables you to bounce flash is with the use of flash umbrellas, a common studio accessory.

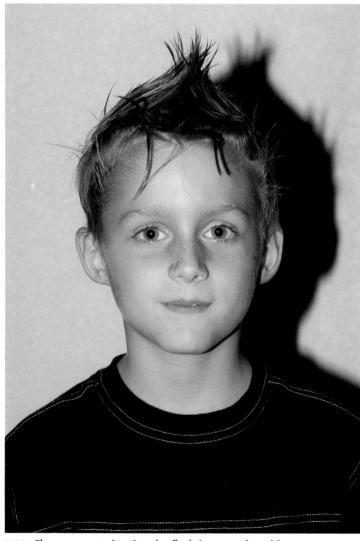

3.19 Close up portrait using the flash in normal position

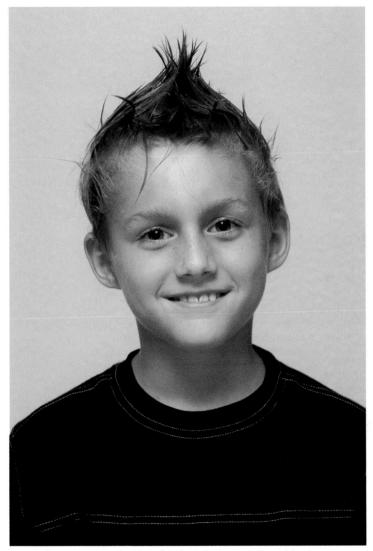

3.20 Close up portrait using the flash in bounced position

When to use bounce flash

You have many situations where a bounced flash is more desirable, especially when taking portraits or snapshots. These situations include:

Camera is close to the subject. If you're positioned close to your subject when taking photos, having your Speedlight pointed directly at the subject can result in a washed out or over lit result. Bouncing the direction of the flash off the ceiling (or even a wall) can help soften the light.

68 Part II → Creating Great Photos with the Creative Lighting System

3.21 Interior of Sun Studios in Memphis, Tennessee, shot with direct flash

3.22 Interior of Sun Studios in Memphis, Tennessee, shot with bounced flash

- Even illumination is desired. If you're taking a photo of a scene where you want more even lighting throughout the frame, bounce flash helps you more evenly illuminate the entire area. Examples are when taking photos where you want both the foreground and background evenly lit. Using a bounced flash results in more balanced lighting in both the foreground and background.
- **Shooting portraits.** Directly lit portrait subjects can result in harsh skin tones. Speedlights do a great job in illuminating your subjects, but when it comes to portraits, too good of a job sometimes isn't wanted. A well-exposed portrait using a Speedlight can result in harsh skin tones. To achieve that softened portrait look, bounce your Speedlight off the ceiling.

Camera and Speedlight settings

When you have the SB-800 or SB-600 mounted on your camera, you can easily tilt the flash head to bounce the light off the ceiling or even the walls. When bouncing light off the ceiling, position the flash head to a 50- to 60-degree angle. For best results, bounce the flash off surfaces that are 3 to 7 feet from the flash.

When using bounce flash, you need to position your Speedlight flash head, make camera settings, and make adjustments to your Speedlight:

- 1. Set your camera's exposure mode to the desired setting. Whether you prefer using Aperture, Program, Automatic, or Shutterpriority mode, make sure you have your desired exposure mode set in your camera.
- 2. Set the white balance. Set your digital camera's white balance setting to Flash or Auto. Setting your digital camera to a Flash white balance setting fixes the camera at the same color temperature as the light emitted by the Speedlight.
- Set the flash mode. Make sure that the flash mode set on your Speedlight is set to TTL or Auto Aperture. You can toggle to the desired flash mode by pressing the Mode button on your SB-800 or SB-600 Speedlight.
- 4. Position the flash head. Tilt or rotate the Speedlight's head by pressing the lock release button and positioning the flash head to the desired position. Both the SB-600 and the SB-800 Speedlights can tilt up 90 degrees (straight up) and rotate horizontally 180 degrees to the left and 90 degrees to the right.

5. Take a test shot. Take a photo and review the results on your digital camera's LCD (if you are using a digital camera). If the image appears under or overexposed, you can adjust the output of the flash by adjusting the flash compensation or by adjusting the aperture setting on your camera. When using bounce flash, you lose two to three stops of light (bouncing light results in less light illuminating the subject as opposed to using normal flash, thus losing two-three stops, measured by aperture settings).

To compensate for light loss, you can increase your cameras exposure compensation to increase the amount of light your flash emits to make up for the loss in exposure. Alternatively, you can change your cameras exposure mode to manual and then adjust the aperture setting to stop down your aperture a few stops until you get the desired results.

Explaining Flash Exposure and Specifications

Flash exposure can seem mystifying when you first attempt to use a flash. You need to know a lot of settings and use different formulas to get the right exposure. After you know what the numbers mean and where to plug them, it becomes quite easy.

I start out by explaining the different aspects that involve obtaining the right flash exposure. Of course, if you are using your Speedlight in the TTL mode, all of these calculations are done for you, but it's always good to know how to achieve the same results manually. When you know this information, you can use any flash and get excellent results.

In the following sections I explain how to use the guide number, the distance from the Speedlight to the subject, and the aperture to determine the proper flash exposure.

Guide number

The guide number (GN) is a numeric value that represents the amount of light emitted by the flash. You find the GN for your specific Speedlight in the owner's manual. The GN changes with the ISO sensitivity, so that the GN at ISO 400 is greater than the GN of the same Speedlight when set to ISO 100. The GN also differs depending on the zoom setting of the Speedlight. Tables 3.1 and 3.2 break down the guide numbers according to the flash output setting and the zoom range selected on the Speedlight.

Tip

If you have access to a flash meter, you can determine the GN of your Speedlight at any setting by placing the meter ten feet away and firing the flash. Next, take the aperture reading from the flash meter and multiply by ten. This is the correct GN for your flash.

Table 3.1 SB-600 Guide Numbers (at ISO 100)

Flash	
Output	
Level	Zoom Head Position

Level	Loom He	du Fosition					
	14*	24	28	35	50	70	85
M 1/1	14.0 M	26.0 M	28.0 M	30.0 M	36.0 M	38.0 M	40.0 M
	45.9 Ft	85.3 Ft	91.9 Ft	98.4 Ft	118.1 Ft	124.7 Ft	131.2 Ft
M 1/2	9.9 M	18.4 M	19.8 M	21.2 M	25.5 M	26.9 M	28.3 M
	32.5 Ft	60.4 Ft	65.0 Ft	69.6 Ft	83.7 Ft	88.3 Ft	92.8 Ft
M 1/4	7.0 M	13.0 M	14.0 M	15.0 M	18.0 M	19.0 M	20.0 M
	23.0 Ft	24.7 Ft	45.9 Ft	49.2 Ft	59.1 Ft	62.3 Ft	65.6 Ft
M 1/8	4.9 M	9.2 M	9.9 M	10.6 M	12.7 M	13.4 M	14.1 M
	16.1 Ft	30.2 Ft	32.5 Ft	34.8 Ft	14.7 Ft	44.0 Ft	46.3 Ft
M 1/16	3.5 M	6.5 M	7.0 M	7.5 M	9.0 M	9.5 M	10.0 M
	11.5 Ft	21.3 Ft	23.0 Ft	24.6 Ft	29.5 Ft	31.2 Ft	32.8 Ft
M 1/35	2.5 M	4.6 M	4.9 M	5.3 M	6.4 M	6.7 M	7.1 M
	8.2 Ft	15.1 Ft	16.1 Ft	17.4 Ft	21.0 Ft	22.0 Ft	23.3 Ft
M 1/64	1.8 M	3.3 M	3.5 M	3.8 M	4.5 M	4.8 M	5.0 M
	5.9 Ft	10.8 Ft	11.5 Ft	12.5 Ft	14.8 Ft	15.7 Ft	16.4 Ft

^{*} With wide flash adapter

Aperture

Another factor that determines the proper flash exposure is the aperture setting. The wider the aperture, the more light falls on the sensor. The aperture or f-stop number is a ratio showing the fractional equivalent of the opening of the lens compared to the focal length. Are you confused? It's actually pretty simple:

The lens opening at f/8 is the same as 1/8 of the distance of the focal length of the lens. So, if you have a 50mm lens, the lens opening at f/8 is 6.25mm. 50 divided by 8 equals 6.25.

All of the math aside, all you really need to know is this: if your Speedlight output is going to remain the same, in order to lessen the exposure, you need to stop down the lens to a smaller aperture or move the Speedlight further away from the subject.

Distance

The third part in the equation is the distance from the light source to the subject. The closer the light is to your subject the more exposure you have. Conversely, the further away the light source is, the less illumination your subject receives. This is due to the *Inverse Square Law*, which states that the quantity or strength of the light landing on your subject is inversely proportional to the square of the distance from the subject to the Speedlight.

Table 3.2 SB-800 Guide Numbers (at ISO 100)

Flash Output Level Zoom Head Position

	7001111007	cad i osidoi									
	*-	2**	14***	17***	24	28	35	20	70	85	105
N 1/1	12.5 M 41 Ft	16 M 52 Ft	17 M 56 Ft	19 M 62 Ft	30 M 96 Ft	32 M 105 Ft	38 M 125 Ft	44 M 144 Ft	50 M 165 Ft	53 M 174 Ft	56 M 184 Ft
M 1/2	8.8 M 29 Ft	11.3 M 37 Ft	12 M 39 Ft	13.4 M 44 Ft	21.2 M 70 Ft	22.6 M 74 Ft	26.9 M 88 Ft	31 M 102 Ft	35.4 M 116 Ft	37.5 M 126 Ft	40 M 131 Ft
M 1/4	6.3 M 21 Ft	8.0 M 26 Ft	8.5 M 28 Ft	9.5 M 31 Ft	15.0 M 49 Ft	16 M 52 Ft	19 M 62 Ft	22 M 72 Ft	25 M 82 Ft	26.5 M 87 Ft	28 M 92 Ft
M 1/8		5.7 M 19 Ft	6.0 M 20 Ft	6.7 M 22 Ft	10.6 M 35 Ft	11.3 M 37 Ft	13.4 M 44 Ft	15.6 M 51 Ft	17.7 M 58 Ft	18.7 M 61 Ft	19.8 M 65 Ft
M 1/16		4.0 M 13 Ft	4.3 M 14 Ft	4.8 M 16 Ft	7.5 M 25 Ft	8.0 M 26 Ft	9.5 M 31 Ft	11 M 36 Ft	12.5 M 41 Ft	13.3 M 44 Ft	14 M 46 Ft
M 1/32		2.8 M 9 Ft	3.0 M 10 Ft	3.4 M 11 Ft	5.3 M 17 Ft	6.0 M 20 Ft	6.7 M 22 Ft	7.8 M 26 Ft	8.8 M 29 Ft	9.4 M 31 Ft	9.9 M 32 Ft
M 1/64	1.6 M 5 Ft	2.0 M 7 Ft	2.1 M 7 Ft	2.4 M 8 Ft	3.7 M 12 Ft	4.0 M 13 Ft	4.8 M 16 Ft	5.5 M 18 Ft	6.3 M 21 Ft	6.6 M 22 Ft	7.0 M 23 Ft
M 1/128		1.4 M 5 Ft	1.5 M 5 Ft	1.7 M 6 Ft	2.6 M 8.5 Ft	2.8 M 9 Ft	3.4 M 11 Ft	3.9 M 13 Ft	4.4 M 14 Ft	4.7 M 15 Ft	4.9 M 16 Ft

 $[\]ensuremath{^{*}}$ With Nikon diffusion dome and wide flash adapter

^{**} With Nikon diffusion dome

^{***} With wide flash adapter

In simpler terms this means you divide one by the distance then square the result. So if you double the distance, you get 1/2 squared, or 1/4 of the total light; if you quadruple the distance, you get 1/4 squared or 1/16 of the total light. This factor is important because if you set your Speedlight to a certain output, you can still accurately determine the exposure by moving the Speedlight closer or further as needed.

GN ÷ **Distance** = **Aperture**

Here's where it all comes together! You take the GN of your flash, divide by the distance of the subject, and you get the aperture at which you need to shoot. Due to the commutative properties of math, you can change this equation to find out what you want to know specifically.

- ♦ Aperture × Distance = GN
- ♦ Aperture ÷ GN = Distance
- ♦ GN ÷ Distance = Aperture

Sync Speed

The sync speed of your camera is the fastest shutter speed you can shoot with and still get the full exposure of the flash. The sync speed is based on the limitations of the shutter mechanism. The sync speed on different camera bodies differs with the type of shutter mechanism used. The D70/D70s uses a combination mechanical and electronically controlled shutter system that enables it to sync up to 1/500 of a second, much faster than the sync speed of the rest of the Nikon camera bodies, all of which sync up to 1/250 of a second.

When using Nikon Speedlights, the camera body does not let you set the shutter speed faster than the rated sync speed. When a non-dedicated flash or an external strobe is used via the PC sync, it is possible to set your camera to a shutter speed higher than the rated sync speed. The result is an incompletely exposed image.

Fill flash

When shooting outdoors on a sunny day using the sun as your main light source, you usually get images that are very high in contrast. The shadows are invariably much darker than they should be. In order to overcome this, a technique called fill flash is used. The SB-800 and SB-600 have a setting for doing balanced fill flash (TTL BL) that works very well. When using the Manual setting on your Speedlight, you can also use fill flash.

To do fill flash manually:

- 1. Position your subject so that the sun is lighting your subject how you like. When shooting a portrait try not to have the sun shining directly in their eyes, as this causes them to squint.
- 2. Use your camera's light meter to determine the correct exposure. A typical exposure for a sunny day at ISO 100 is f/16 at 1/125 sec.
- Determine the proper exposure for your Speedlight. Use the GN
 Distance = Aperture formula.

Note

You can determine the approximate distance to your subject by looking at the lens after it has been focused on the subject. Most lenses have a distance scale on them or you can use a tape measure.

4. After you determine the exposure, set the flash exposure at 1/3 to 2/3 of a stop under the proper exposure. The actual amount of underexposure needed depends on the brightness of the sun and the darkness of the shadows.

5. Take the picture and preview it on the LCD. This helps you to decide if you need more or less flash exposure to fill in the shadows. Change the exposure compensation and take another photograph if you aren't satisfied.

Note

Be sure the flash head zoom is set to the proper focal length for the lens in use.

Wireless Flash Photography with the CLS

ou're probably wondering in what situations you might want to use multiple wireless Speedlights? Well, the answer is, you can use them for almost any type of photography and in many different situations. For portraits, you need to be able to move your lights around in order to get the best lighting or specific lighting patterns. You need to be able to adjust your fill light to create a mood. In action photography, if you know where the action is taking place, you can set up your Speedlights at that location and move around to capture different angles without changing the direction or output of your light. When doing still life photography, you can set up two or more Speedlights to fill in the shadows and bring out texture and detail. In architectural photography, you may need to set up a couple of Speedlights to illuminate dark corners so that your overall lighting coverage is even.

As you can see, there are many practical applications for multiple wireless flash units. If you have a need to light it, you can probably think of a way that wireless flash can make it easier for you. After you get the Speedlight off of the camera, you can start to be more creative in shaping the light on your subject. The fact that there are no wires and no need for electrical outlets is an added bonus.

With CLS, gone are the days of carrying around an expensive light meter, reading the output of each single strobe and making adjustments on the power pack that the strobe heads are attached. The camera working in conjunction with the commander unit does all the metering for you. The camera gets

In This Chapter

How CLS works with your camera

Flash setup in the CLS

you in the ballpark; all you have to do is fine-tune. The fine-tuning is made easy with CLS also. All of your adjustments are made from right behind the camera with just one glance at your LCD preview.

The Nikon Creative Lighting System is a very complex tool, but all of the complexities are taken care of within the camera system itself. CLS takes twenty minutes worth of metering and adjusting and does it all for you in a matter of milliseconds. You can use all this saved time to come up with more creative images.

This chapter provides an overview of how Nikon's CLS uses the camera and commander unit to communicate with the remote units resulting in almost perfect exposures every time.

How CLS Works with Your Camera

The Nikon CLS isn't a specific entity or setting on your camera. All of the D2 series, dSLRs as well as the D70/D70s, D50, and D200 dSLRs are compatible with CLS. To date, the only film camera that's compatible with CLS is the F6. Although all of these cameras are compatible with CLS, not all of them share the same functions.

Basically, the Nikon CLS is a communication device. When set to i-TTL, the camera body relays information to the commander unit. The commander unit tells the remotes what to do. The shutter opens and the remotes fire. Sounds fairly simple, doesn't it? And, in all actuality, it is for you, but it's definitely a great feat of electronic engineering.

Broken down into more detail, the whole system is based on pulse modulation. *Pulse modulation* is a fancy term for the Speedlight firing rapid bursts of light in a specific order. Using these pulses, the commander unit, be it a SB-800, SU-800, or a built-in Speedlight, conveys instructions to the remote units.

The first instruction the commander sends out to the remotes is to fire a series of monitor pre-flashes to determine the exposure level. These pre-flashes are read by the camera's i-TTL metering sensors, which combine readings from all of the separate groups of Speedlights along with a reading of the ambient light.

The camera tells the commander unit what the proper exposure needs to be. The commander unit then, via pulse modulation, relays specific information to each group about how much exposure to give the subject. The camera then tells the commander when the shutter is opened, and the commander unit instructs the remote flashes to fire at the specified output.

All of this is done in a split-second. Of course when you press the Shutter button, it looks like the flashes fire instantaneously. There's no waiting for the shutter to fire while the Speedlights do their calculations.

Overview of Flash Setup in the CLS

When setting up for a photo shoot, you first need to decide how many Speedlights you want to use. For most small projects you need at least two Speedlights, one for your main or key light and one for a fill light. When doing portraits you may want to use as many as four Speedlights: one for your key light, one for your fill, one for a background light, and one for a hair light. Depending on what camera you're using, this can mean five Speedlights, including one to be used as a commander unit. This is, of course, an extreme example. You can achieve great results using the built-in flash as a commander and one Speedlight.

If you're using a D2X, D2H, or a D50, you'll need to add either an SB-800 Speedlight or an SU-800 Commander to control the remote Speedlights.

Step 1: Choose a Flash mode

Now you need to decide which flash mode you want to use. The three flash modes available when using the Advanced Wireless System are TTL, AA, and M. I recommend using TTL, as it gets you as close as you need to be without the need for making endless adjustments. The Auto Aperture setting tends to underexpose, requiring adjustment of all of the groups. The Manual setting is almost the same as using studio strobes. You need to make exposure calculations to decide what to set the output levels to.

Cross-Reference

For more specifics on using the Flash modes, see Chapter 2.

Step 2: Choose a channel

After you decide which flash mode you want to use, the next step is to decide which channel you want to work on. This decision should be pretty simple. For the most part, it's unlikely you'll be working in close proximity to other photographers, so you can use whatever channel you'd like. In the unlikely event you are working near another

photographer using Nikon CLS, just ask them which channel they're using and use a different one. I usually use channel three simply because when I first started using CLS, I was using a D70, and the built-in Speedlight works as a commander only on channel three. Essentially, it really makes no difference what channel you use as long as there are no other photographers near you using Nikon CLS.

Step 3: Set up groups

The next step is setting up groups. Generally, you want to set your main lights to one group, the fill lights to one group, and any peripheral lights, such as hair and background lights to another group. You want to do it this way so you can adjust the output of the specific lights based on their functions. Your main light is the brightest; probably pretty close to whatever TTL reading your camera comes up with. The fill lights need to be a little under what the TTL reading is, so by setting them to a separate group you can adjust them without altering the exposure of your mains. The background lights may or may not need adjusted depending on the darkness of the background, whether you're shooting high key or low key, and so on. You want these lights in a separate group to enable you make the necessary adjustments without affecting the other two exposures.

Note

When using the built-in Speedlights as a commander there are some limitations to the number of groups available to use. The D70/s allows only one group to be set, and the D200 and D80 allow Speedlights to be set in two groups.

Step 4: Adjust output levels

Now you're ready to adjust the output levels. After you get your channels set, your groups decided, and your lights set up, it's time to take some test shots. If you have everything set to the TTL flash mode, you should be pretty close to the proper exposure. Just make some minor adjustments and you're done. All of these adjustments can be made right at the camera, so there's no need to visit each light to make minor changes.

In the following sections, you go step-bystep into setting up your flashes for commander and remote use, choosing a flash mode, setting channels and groups, and adjusting the output for your specific needs. If using a D200 and you need more than two groups of Speedlights, you also need to use an SB-800 or SU-800. All of the D2 series cameras need a separate commander unit.

Deciding which Speedlight to use as a master (also referred to as a commander) and which one to use as a remote is pretty easy. If you need a commander unit, you must use the SB-800 as the SB-600 only functions as a remote in the wireless mode.

When setting up the Speedlights, you generally set all of the settings in one trip through the Custom Settings menu. If you need to go back and change any settings, some steps will need to be repeated.

Setting Up Masters and Remotes

First of all, you need to decide which Speedlights you're going to use and for what purpose you're going to use each Speedlight. One consideration is which camera body you are using.

- When using a D70/D70s or D200, you can use the built-in flash for a commander. This means you can use any number of SB-800s or SB-600s as remotes.
- If you're using the D70/D70s and you need more than one group of Speedlights, you have to use an SB-800 or SU-800 as a commander unit.

D70/D70s as a master

To use the D70/D70s built-in flash as a master:

- Turn on the camera and press the Menu button to the left of the LCD.
- Enter the CSM (Custom Settings menu) by using the multiselector to scroll down to the pencil icon, and press the multiselector to the right to choose the proper menu number.
- Scroll down to CSM number
 19 Flash mode and push the multi-selector right to select which mode your built-in
 Speedlight functions in.
- Scroll down to Commander mode and push the multiselector right to choose the desired flash mode.

 Select the desired mode: TTL, AA, or M. Push the multi-selector right to save settings. Note that when M is selected you must

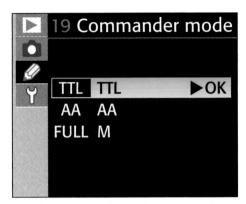

4.1 The Commander mode menu on the D70

choose the flash output level before you can save the settings.

Note

When using the D70/D70s builtin flash as a commander, be sure to set your remote Speedlights to Channel 3 Group A, otherwise the Speedlight won't fire.

D200 as a master

To use the D200 built-in flash as a master:

- Turn on the camera and press the Menu button to the left of the LCD.
- Enter the CSM (Custom Settings menu) by using the multiselector to scroll down to the Pencil icon.

 Using the Multi-selector button, highlight CSM e – Bracketing/ Flash and push the multiselector right to select the flash menu.

Note

This CSM is also where you adjust the Channels as well as the group settings, modes, and flash output compensation.

- Scroll down to setting e3 Built-in Flash and push the multi-selector right to select which mode the built-in Speedlight functions in.
- Highlight Commander mode and push the multi-selector right.
 This brings you to the wireless setting menu.
- Use the multi-selector left and right buttons to highlight the mode setting for the built-in flash.
- Use the multi-selector to move up or down to select the preferred mode.

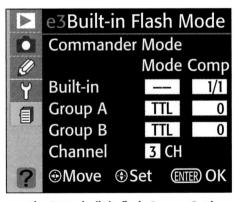

4.2 The D200 built-in flash Custom Settings menu

- Use the multi-selector left and right to highlight the settings for groups A and B and also to set the channels.
- Press the Enter button to set the changes. Be sure to set your remote Speedlights to the proper groups and channels.

SB-800 as a master

To use the SB-800 as a master flash:

- Enter the CSM on the Speedlight.
 Press the Select button (SEL) for
 two seconds to get there.
- Use the + or and the left and right zoom buttons to select the wireless settings menu. The menu has the icon of a flash with an arrow next to it.
- Use the + or button to select the Master option.
- After Master mode is selected, press the Mode button to choose the desired flash mode (TTL, M, or AA).
- 5. Press the Select button to highlight the Group A settings. Change these setting as necessary. Use the same procedures to change groups B and C.
- Press the Select button again to highlight a Channel setting. Choose the proper channel using the + or – buttons.
- Press the On/Off button to apply the settings.

For instructions on setting up Speedlights as wireless remotes, see Chapter 2.

Setting Up Flash Modes

The flash mode is used to decide how the Speedlights are going to be set to the proper exposure level. In the TTL mode, the remote flashes fire test shots and the camera meters it through the lens using its exposure sensor. and then sets the output for you. In the M mode, you need to decide the proper exposure by using a light meter or the quide number ÷ distance = aperture equation. You can input the proper exposure levels into the commander unit and the commander tells the remotes at what power level to fire. When using the SB-800 as a wireless remote, you also have the AA or auto aperture mode. When using this mode, you set the aperture you want to shoot at and the camera decides the probable correct exposure. I don't recommend using this setting as the flash tends to be to over expose, requiring changing the exposure compensation repeatedly until your LCD shows acceptable results.

The guide number ÷ distance = aperture equation is explained in detail in Chapter 3.

Setting the flash modes of the wireless remotes is achieved through the settings menu of the commander unit, be it the SB-800, SU-800, or a built-in Speedlight.

Different flash modes can be set for groups, for example, Group A can be set to TTL and Group B can be set to M at the same time.

SB-800 in Master mode

To set the flash mode on the SB-800 in Master mode:

- Enter the CSM on the Speedlight.
 Press the Select button (SEL) for
 two seconds to get there.
- Use the + or and the left and right zoom buttons to choose the wireless settings menu. The menu has the icon of a flash with an arrow next to it.
- 3. Use the + or button to select Master.
- After the setting is in the master mode, press the mode button to choose the desired flash mode. Choose from TTL, M, or AA.
- Press SEL to highlight the Group A settings. Change these setting as necessary. Use the same procedures to change Groups B and C.
- Press the SEL button again to highlight the Channel settings. Choose the proper channel using the + or - buttons.
- 7. Press the On/Off button to set.

Using a built-in Speedlight

To set the flash modes using the built-in Speedlight on the D70/D70s:

- Turn on the camera and press the Menu button to the left of the LCD.
- Enter the CSM (Custom Settings menu). Use the multi-selector to scroll down to the pencil icon.

- Scroll down to CSM number 19 Flash mode and push the multiselector right.
- Scroll down to Commander mode and push the multiselector right.
- 5. Select the desired flash mode: TTL, AA, or M. Push the multi-selector right to save settings. Note that when M is selected you must choose the flash output level before you can save the settings.

To set the flash modes using the built-in Speedlight on the D200:

- Turn on the camera and press the Menu button to the left of the LCD.
- Enter the CSM (Custom Settings menu). Use the multi-selector to scroll down to the pencil icon.
- Use the multi-selector button to highlight CSM e - Bracketing/ Flash. Push the multi-selector right.
- Use the multi-selector to scroll down to setting e3 – Built-in Flash. Push the multi-selector right.
- Use the multi-selector to highlight Commander mode. Push the multi-selector right.
- 6. Use the multi-selector to highlight the built-in flash mode. Use the multi-selector to move up and down to select the preferred flash mode. Press the Enter button to set the changes.

Setting Channels

After you get the flash mode set, you decide on the channel. As discussed earlier, you have four channels from which to choose. All four channels operate exactly the same so it doesn't matter which channel you use as long as all of your remote Speedlights are set to the same one.

SB-800 in Master mode

To set channels on the SB-800 in Master mode:

- Enter the CSM on the SB-800 Speedlight. Press the Select button (SEL) for two seconds to get there.
- Use the + or and the left and right Zoom buttons to choose the wireless settings menu. The menu has the icon of a flash with an arrow next to it.
- Use the + or buttons to select Master.
- After the setting is in the Master mode, press the Mode button to choose the desired flash mode (TTL, M, or AA).
- Press SEL to highlight the Group A settings. Change these settings as necessary. Use the same procedures to change Groups B and C.
- Press SEL again to highlight the Channel settings. Choose the proper channel using the + or – buttons.
- Press the On/Off button to set the changes.

Using a built-in Speedlight

The D70 can only be used on one channel: channel 3. Be sure to set your remote Speedlight to channel 3, Group A.

To set channels using the built-in Speedlight on the D200:

- Turn on the camera and press the Menu button to the left of the LCD.
- Enter the CSM using the multiselector to scroll down to the pencil icon.
- Use the multi-selector button to highlight CSM e - Bracketing/ Flash. Press the multi-selector right.
- Use the multi-selector to scroll down to setting e3 - Built-in Flash. Press the multi-selector right.
- Highlight Commander mode. Press the multi-selector right.
- Highlight the Channel setting by pressing the mulit-selector to the right.
- Select the channel you want to use.
- Set the channel by pressing the Enter button.

Wireless remote flash

To set the channels on the SB-600 wireless remote flash:

 Go into the CSM by pressing the Zoom and – buttons simultaneously for about two seconds. Press the + or - buttons to cycle through the CSM until you see a squiggly arrow that says Off above it.

4.3 The Off icon/menu setting on the SB-600

- Press the Zoom or Mode buttons to turn the remote setting on.
- Press the Power button. This brings you to the wireless remote settings menu.
- Press the Zoom button to set the flash zoom to match the focal length of the lens you're using.
- Press the Mode button to select the channel. When the channel is ready to be changed it flashes.
- 7. Use the + or buttons to change the channel.
- 8. Press the Mode button again. This sets the channel and moves you to the Group setting. The group letter flashes when ready to be changed.
- Use the + or to change the setting.
- Press the Mode button again to set the changes.

To set the channels on the SB-800 wireless remote flash:

- Enter the CSM on the SB-800 Speedlight. Press the Select button (SEL) for two seconds to get there.
- 2. Use the + or and the left and right zoom buttons to choose the wireless settings menu. The menu has the icon of a flash with an arrow next to it.
- Use the + or button to select Remote.
- After the setting is in the remote mode, press SEL to highlight the channel number.
- Use the + or buttons to select the desired channel.
- Press SEL again to set the channel and highlight the Group settings.
- 7. Select the Group you want the flash used with. Choose A, B, or C.

Setting Up Groups

You use the Group settings to control the remote Speedlights individually, so the output of each group can be varied to achieve the desired lighting pattern. Whether you have one Speedlight in a group or one hundred, all of the Speedlights in that particular group will function the same. This includes the flash mode and any exposure compensation that has been set.

The Group setting must be set on each individual Speedlight in order for them to function properly.

SB-600

To set up a group using the SB-600:

- Go into the CSM by pressing the Zoom and – buttons simultaneously for about two seconds.
- Press the + or buttons to cycle through the CSM until you see a squiggly arrow that says Off above it.
- Press the Zoom or Mode buttons to turn the remote setting on.
- Press the Power button. This brings you to the wireless remote settings menu.
- Press the Zoom button to set the flash zoom to match the focal length of the lens you're using.
- Press the Mode button to select the channel. When the channel is ready to be changed, it flashes.
- 7. Use the + or buttons to change the channel.
- 8. Press the Mode button again. This sets the channel and moves you to the Group setting. The group letter flashes when ready to be changed.
- Use the + or to change the setting.
- Press the Mode button again to set the changes.

SB-800

To set up a group using the SB-800:

 Enter the CSM on the SB-800 Speedlight. Press the Select button (SEL) for two seconds to get there.

- Use the + or and the left and right zoom buttons to choose the wireless settings menu. The menu has the icon of a flash with an arrow next to it.
- Use the + or button to select Remote.
- After the setting is in the remote mode, press SEL to highlight the channel number.
- Use the + or buttons to select the desired channel.
- Press SEL again to set the channel and highlight the Group settings.
- 7. Select the Group you want the flash used with. Choose A, B, or C.

Setting Output Level Compensation

You use output level compensation to finetune the settings to achieve the desired look of the overall image. The output levels can be adjusted for each individual group.

As with the flash modes the output compensation must be set in the commander unit. The output levels apply to all remote flash units in the group.

With the SB-800 set to Master

To set output level compensation using the SB800 set to Master:

- Press the SEL button on the master flash to highlight M.
- Use the + or buttons to adjust the output level.

- Press the SEL button again to highlight Group A.
- 4. Use the + or buttons to adjust the output level.
- Repeat the steps to adjust Groups B and C.

Using a built-in Speedlight

To set output level compensation using the built-in Speedlight on a D70/D70s:

- Turn on the camera and press the Menu button to the left of the LCD.
- Enter the CSM using the multiselector to scroll down to the pencil icon.

- Scroll down to CSM number 19 Flash mode and push the multiselector right.
- Scroll down to Commander mode and push the multiselector right.
- Select the desired flash mode: TTL, AA, or M. Push the multiselector right to save settings.
- While pressing the D70/D70s flash level button, use the front control dial to set the desired level of exposure compensation.

Because the D70/D70s built-in Speedlight only controls one group of remote Speedlights, the output compensation level applies to all remote Speedlights.

4.4 Flash exposure level compensation button on the D70

86 Part II + Creating Great Photos with the Creative Lighting System

To set output level compensation using the built-in Speedlight on a D200:

- Turn on the camera and press the Menu button to the left of the LCD.
- Enter the CSM using the multiselector to scroll down to the pencil icon.
- Use the multi-selector button to highlight CSM e - Bracketing/ Flash. Push the multi-selector right.
- Use the multi-selector to scroll down to setting e3 – Built-in Flash. Push the multi-selector right.
- Use the multi-selector to highlight Commander mode. Push the multi-selector right.

- Use the multi-selector to highlight the built-in flash mode.
 Use the multi-selector up and down to select the preferred flash mode.
- Press the multi-selector right to highlight the compensation levels. Press the multi selector up and down to adjust the exposure compensation.
- Repeat steps six and seven to adjust Groups A and B.

If the group is set to "---" the flash is not set to fire, therefore, you cannot select the exposure compensation level to adjust it.

Setting Up a Wireless Studio

portable studio is a handy thing to have. It enables you to go on location and photograph your subjects in their own environment. This way you can take your studio to your client. A portable studio should be exactly that—portable. You should be able to fit everything you need into a minimum amount of space and be able to transport it quickly and with little effort.

The great thing about the Nikon CLS, or Creative Lighting System, is that it enables you to make your portable studio even more portable and easier to set up. You no longer need bulky studio lights in order to create professional looking images. The Nikon SB-600 and SB-800 are small and affordable, and best of all they can be used wirelessly off camera.

With the prosumer Nikon dSLR camera bodies, such as the D70, D70s, and the D200, the built-in Speedlight acts as a controller for the CLS-compatible flashes. Nikon's pro level cameras lack a built-in Speedlight, therefore, you have to purchase an SU-800 wireless commander or use an SB-800 as the commander. While the consumer level D50 has a built-in Speedlight, for some reason Nikon chose not to have it function as a commander. As with the pro level cameras, you can achieve this function with the SU-800 or the SB-800

Note

The SB-600 functions as a remote flash only when using CLS. It cannot be used as a commander for other flash units.

In This Chapter

Introduction to the portable studio

Choosing umbrellas

Using a softbox

Backgrounds and background stands

Space requirements

Traveling with your wireless studio

Introduction to the Portable Studio

A portable studio should include, but should not be limited to at least one Speedlight, a reflector of some sort to fill in the harsh shadows created by strobes, an umbrella or softbox to soften the light for a more pleasing effect, and one or more light stands.

Ideally, your portable studio has at least two or more Speedlights, depending on the types of subjects you shoot. Also handy, but not absolutely necessary for all subjects, are backgrounds and background stands.

Tip

Although I recommend using a professional reflector disk, you can use lots of different items as a reflector. White foam board (available at any art supply store) works particularly well. In a pinch almost anything white or silver works—a lid from a Styrofoam cooler or even a white t-shirt.

5.1 These reflector disks fold up to a very convenient size.

Choosing Umbrellas

Photographic umbrellas are basically the same as an umbrella you would use to keep the raindrops from falling on your head, but photographic umbrellas are coated with a material to maximize reflectivity. Photographic umbrellas are used to diffuse and soften the light that is emitted from the light source, be it continuous or strobe lighting.

If you are already familiar with the various pieces of studio photography equipment, you likely already know that umbrellas do the same thing that a softbox does. What you may not know is that umbrellas are more affordable and are easier to use than softboxes, as an accessory for your Nikon Speedlight. (This isn't to say, though, that softboxes aren't useful—they are.)

There are three types of umbrellas to choose from:

- Standard. The most common type of umbrella has a black outside with the inside coated with a reflective material that is usually silver or gold in color. These are designed so that you point the Speedlight into the umbrella and bounce the light onto the subject, resulting in a non-directional soft light source.
- Shoot-through. Some umbrellas are manufactured out of a one piece translucent silvery nylon that enables you to shoot through the umbrella, such as a softbox. You can also use this type of umbrella to bounce the light, as mentioned previously.

◆ Convertible. The third type of umbrella is a convertible umbrella. This umbrella has a silver or gold lining on the inside and a removable black cover on the outside. You can use these umbrellas to bounce light or as a shoot-through when the outside covering is removed.

Photographic umbrellas come in various sizes usually ranging from 27 inches all the way up to 12½ feet. The size you use is dependent on the size of the subject and the degree of coverage you would like to get. For standard headshots, portraits, and small to medium products, umbrellas ranging from 27 inches to about 40 inches supply plenty of coverage. For full length portraits and larger products, a 60- to 72-inch umbrella is generally recommended. If you're photographing groups of people or especially large products, you will need to go beyond the 72-inch umbrella.

The larger the umbrella, the softer the light falling on the subject from the Speedlight is. It is also true that the larger the umbrella, the less light that falls on your subject. Generally the small to medium umbrellas lose about a stop and half to two stops of light. Larger umbrellas generally lose two or more stops of light because the light is being spread out over a larger area.

Smaller umbrellas tend to have a much more directional light than do larger umbrellas. With all umbrellas, the closer you have the umbrella to the subject the more diffuse the light is.

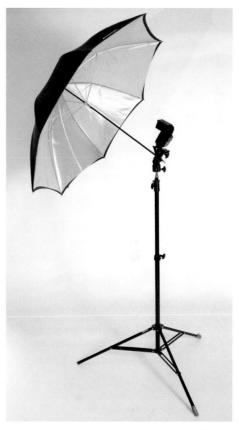

5.2 An SB-600 with a standard umbrella

For setting up a wireless/portable studio, I'm convinced that the umbrella is the way to go. They fold up nice and small, are simple to use, are relatively inexpensive, and attach to the light stand with an inexpensive bracket which is available at any photography store for less than \$15. This bracket also includes a shoe mount for attaching your Speedlight.

Choosing the right umbrella is a matter of personal preference. Some criteria to keep in mind when choosing your umbrella include the type, size, and portability. You also want to consider how it works with your Speedlight. For example, regular and convertible umbrellas return more light to the subject when bounced, which can be advantageous because a Speedlight has less power than a studio strobe. And, the less energy the Speedlight has to output, the more battery power you save. On the other hand, shoot-through umbrellas lose more light through the back when bouncing, but are generally more affordable than convertible umbrellas

Using a Softbox

Softboxes, as with umbrellas, are used to diffuse and soften the light of a strobe to create a more pleasing light source. Softboxes range in size from small 6-inch boxes that you mount directly onto the flash head to large boxes that usually mount directly to a studio strobe. Softboxes come in a variety of shapes, too—anywhere from a small, square shaped softbox to very large, octagonal softbox designed to simulate umbrellas.

Flash-mount softboxes

The small flash-mounted softboxes are very economical and easy to use. You just attach it directly to the flash head and use it with your flash mounted on the camera or on a flash bracket. This type of softbox is good to use while photographing an event, informal portraits, wedding candids, or just plain old snapshots of your friends and family. You generally lose about one stop of light with these and should adjust your flash exposure

compensation accordingly. For shooting small still life subjects or simple portraits, this may be all you need to get started with your wireless/portable studio.

Stand-mounted softboxes

When photographing in a studio type of setting you really need a larger softbox that is mounted, along with your Speedlight, onto a suitable light stand. For a larger softbox, you need a sturdier stand to prevent the lighting setup from tipping over. Bogen/Manfrotto, manufacturers of high quality stands and tripods, have a basic six foot stand that works well for this application.

The reason that you may want to invest in a softbox rather than an umbrella for your portable studio is that softboxes provide a more consistent and controllable light than umbrellas do. Softboxes are closed around the light source thereby eliminating unwanted light from being bounced back on to your subject. The diffusion material gives less of a chance of creating hotspots on your subject. A *hotspot* is an overly bright spot on your subject usually caused by bright or uneven lighting.

Softboxes are generally made for use with larger studio strobes. They attach to these strobes with a device called a *speedring*. Speedrings are specific to the type of lights to which they are meant to attach. Luckily for photographers, some companies, such as Chimera, manufacture a type of speedring that mounts directly to the light stand and allows you to attach one or more Speedlights to the light stand as well. You mount the speedring to the stand, attach the softbox to the speedring, attach the Speedlight with the flash head pointed into the softbox, and you're ready to go.

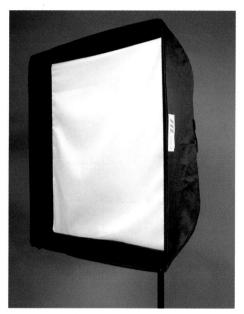

5.3 Stand-mounted softbox

Stand-mounted softboxes come in a multitude of shapes and sizes ranging from squares to rectangles to ovals to octagons. Most photographers use standard square or rectangular softboxes. However, some photographers prefer to use oval or octagonal ones for the way that they mimic umbrellas and give a more pleasing round shape to the catchlights in the eyes. This is mostly a matter or personal preference. I, for one, usually use a medium sized rectangular softbox.

As with umbrellas, the size of the softbox you need to use is dependent on the subject you are photographing. Softboxes can be taken apart and folded up pretty conveniently—most of them come with storage bag that can be used to transport them.

Softbox alternatives

If you are working on a budget, or just aren't sure you are ready to invest in a softbox, a more economical approach is to use a diffusion panel. A diffusion panel is basically a frame made out of PVC pipe with a reflective nylon stretched over it. It functions much in the same way as a soft box, but you have more control over the quality of the light. Because the PVC frame can be disassembled easily and packed away into a small bag for storage or for transport to and from location, it makes it great for the portable studio.

Diffusion panels are usually about six feet tall and have a base which allows it stand up without the need of a light stand. The diffusion panel is placed in front of the subject. Your Speedlight is then mounted on a light stand using the AS-19 adaptor that is supplied with it. You can move the Speedlight closer to the diffusion panel for more directional light or further away for a softer and more even light. For a full length portrait, you should place two Speedlights behind the panel, one near the top and one closer to the bottom.

A diffusion panel can also be used as a reflector when used in conjunction with another light source. Diffusion panels can be purchased at most major camera stores at a fraction of the price of a good softbox.

Tip

If you're feeling crafty, a diffusion panel can be made from items easily found in your local hardware and fabric store. Numerous sites are on the Internet that offer advice on how to construct one.

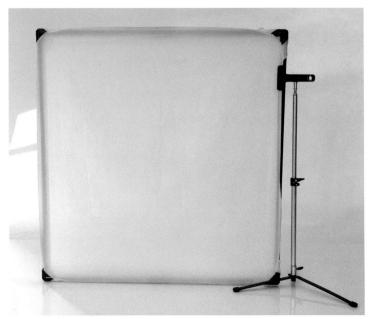

5.4 A diffusion panel

Backgrounds and Background Stands

When you want to isolate the subject, making it the sole focus of the image, use a background. Backgrounds can also be used to compliment the color of an object or to accent a certain feature of the person whose portrait you are taking.

Backgrounds come in almost as many colors and materials as you can imagine. The following sections discuss some of the different types and applications.

Seamless paper backdrops

The most common type of backgrounds are made of paper. Seamless paper backdrops are inexpensive and come in every color imaginable. Standard rolls of background paper range in size from 3-feet to 12-feet wide, and can be as long as 36 feet. The great thing about using paper as a background is that if it gets dirty or torn you can cut it off and pull more down from the roll.

Starting out, getting a roll of neutral grey paper is best. You can use this color for just about any subject without worrying about the color of your subject clashing with the background. White paper is good for photographing high-key subjects, while a black background is good for photographing low-key subjects.

5.5 A seamless paper background

For more information on high key and low key, see Chapter 3.

In order to keep your portable studio manageable, sometimes it might be necessary to cut down your seamless paper backdrop. For example, when I have to travel with my portable portrait studio, I usually take a 53 inch wide by 36 foot roll of seamless and cut it down to 48 inches wide with a hacksaw in order to make it fit into the case that holds my backdrops and stands.

Tip

When shopping for a backdrop, consider www.photography props.com and www.backdropsource.com, both on the Web.

Tip

When using white, grey, or black seamless backgrounds, you can use gels on a Speedlight aimed at the backdrop to add color. A gel is a piece of colored film that you place over the light source in order to change the color. Nikon sells a colored gel kit, the SJ-1, which includes yellow, red, blue, and amber gel filters as well as filters for balancing tungsten and fluorescent with flash from the Speedlight. Many different companies sell these gels at reasonable prices.

Muslin backdrops

Muslin is an inexpensive lightweight cotton material. When used for backdrops, it is usually dyed different colors with a mottled pattern to give the background a look of texture. You can purchase muslin at most well-stocked photography stores or online. If you have very specific needs, there are companies that dye muslin fabric to a custom color of your choice.

Muslin is very convenient to use. It's very lightweight, it folds up easily into a small bundle, and it is pretty durable. You can drape it over your background stand or you can easily tack it to a wall. For a portable studio, this flexibility is very advantageous because the muslin doesn't take up too much valuable space when traveling.

5.6 A muslin backdrop shown in a studio setting

Muslin is very versatile, and although it's much more suited to portraits, it can be used successfully for product shots as well.

Canvas backdrops

Canvas backdrops are very heavy duty. They are usually painted a mottled color that is lighter in the center and darkens around the edges, which helps the subject stand out from the background. These types of

backdrops are almost exclusively used for portraits.

When considering a canvas backdrop, in addition to the weight factor, you should consider the cost as well—they are expensive. Although you can get them in lighterweight smaller sizes, I wouldn't generally recommend using canvas backdrops for a portable studio as they are unwieldy and not very versatile.

Background stands

Background stands, amazingly enough, hold up your backgrounds. Most background stand kits have three pieces: two stands and a cross-bar. The cross-bar slides into a roll of paper or other backdrop and is held up by the stands. The cross-bar has two holes, one at either end, which slide over a support pin on the top of the stand. The crossbar is usually adjustable from 3 to 12½ feet, to accommodate the various widths of backdrops. The stands are adjustable in height up to 10½ feet. Most kits also come with either a carrying case or a bag for maximum portability.

There a varying degrees of quality in background stands. The more sturdy the stand, the more expensive it is. For a portable studio, a decent medium-weight background stand kit suffices.

5.7 A background stand kit with seamless paper backgrounds

Space Requirements

Portable studios, by their very nature, don't require a lot of space to set up. As always, the more space you have, the more comfortable you are.

If your portable studio is going to be set up mostly in one place, such as a spare room in your house, then you're going to want to take measurements of the width of the space to make determinations, such as how wide your backdrop can be. Another consideration is what type of photography you plan to do. If you're going to be photographing full length portraits, for example, the length of the room needs to be longer than if you're planning on photographing mainly head and shoulders portraits.

Setting up indoors

The first thing you want to do when setting up indoors is to find a space wide enough to accommodate your background and stands. Remember that although your backdrop may only be six feet wide, the stands extend two or three feet beyond that. Next, you want to be sure that you have enough room in front of the background to be able to move back and forth to enable you to compose your picture properly.

Depending on the type of indoor photography you are planning, your considerations differ, as the next sections explain.

Portraits

When photographing portraits, you want to use lenses with a longer focal length so you don't get the distortion that wide angle lenses often have. Unfortunately, with longer lenses comes the need for more space.

If you use a long focal length lens to photograph a head and shoulders portrait, you don't want to find your back up against the wall when you only have the head in the frame. For example, if you use an 85mm lens with a D200, you need at least 12 feet between the camera and the subject, two or three feet behind the camera for you, and anywhere from three to six feet between the model and the background to be sure the model isn't casting shadows on the backdrop.

Be sure the area is wide enough to accommodate both the models and the lights comfortably. You want to have enough width to be able to move the lights further away from the model if needed.

When setting up to photograph portraits, you need to first decide how you want your lighting to look. There are five main types of portrait lighting.

These five types are

◆ Shadowless. This lighting is when your main light and your fill light are at equal ratios. Generally, you set up a Speedlight at 45 degrees on both sides of your model. This type of light can be very flattering although it can lack moodiness and drama.

- Butterfly. Also called Hollywood glamour, this type of lighting is mostly used in glamour photography. It gets its butterfly name from the shape of the shadow that the nose casts on the upper lip. You achieve this type of lighting by positioning the main light directly above and in front of your model.
- Loop. Also called Paramount, this is the most commonly used lighting technique for portraits. It was used so extensively by Paramount Studios in Hollywood's golden age, that this lighting pattern became synonymous with the studio's name. This lighting pattern is achieved by placing the main light at a 15-degree angle to the face making sure to keep the light high enough so that the shadow cast by the nose is at a downward angle and not horizontal.
- ♠ Rembrandt. This dramatic lighting pattern was used extensively by the famous artist Rembrandt van Rijn. The lighting is a moody dramatic pattern that benefits from using less fill light. The Rembrandt style is achieved by placing the light at a 45-degree angle aimed a little bit down at the subject. Again I emphasize using little or no fill light. This style is by far my favorite type of lighting.
- Split. This is another dramatic pattern that benefits from little or no fill. You can do this by simply placing the main light at a 90-degree angle to the model.

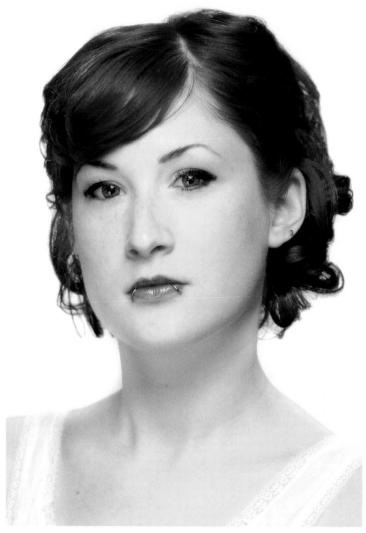

5.8 A portrait using shadowless light

5.9 A portrait using butterfly lighting

5.10 A portrait using loop lighting

5.11 A portrait using Rembrandt lighting

5.12 A portrait using Split lighting

Small products

Photographing small products requires a lot less room than photographing people. You can move the lights much closer, and you can use a close-up or macro lens. Even when using a lens with a long focal length, you are able to be closer to the subject, thereby reducing the amount of space you need.

Using an 80-200mm lens with a D200, you need at least six feet from the camera to the subject and two to three feet behind the camera for you. That's almost half the amount of space you need to do portraits!

The best place to start out lighting a product is to place the main light above and a little behind the product. This placing simulates a natural light, similar to sunlight, by which all lighting is judged. The next step is to note where the deep shadows are and to fill them in a bit. You do this so you can achieve detail in the shadows and not have them go completely black. You can either use a fill light or you can bounce or reflect light from the main light into the shadow areas.

Remember, a little experimentation never hurts. Move the lights around and try new and different methods.

Setting up outdoors

The best aspect about having a portable studio is that you can take it anywhere. With the Nikon CLS system, you can bring your lighting setup outside and not worry about having somewhere to plug in. When shooting outdoors, gone are the space restrictions you have indoors, but outdoor shooting has pitfalls all its own.

When you use your SB-800 or SB-600 on camera, you can use the sun as your main light, set the flash to TTL BL and shoot. If you use them off camera with stands, you need to be sure to set them on firm level ground. Also, when using a softbox or umbrella, be very conscious of the wind. The wind can take the umbrella and bring your Speedlight crashing to the ground.

When shooting outdoors you can use the same lighting situations as noted in the section on portraits, but you need to pay particular attention to the sun. Different types of sunlight have different pitfalls:

Bright sunlight. Bright sunlight can cause serious problems with exposure when using flash. When in bright sunlight your camera may call for an exposure that's higher than your camera's rated flash sync speed. The D70 and D50 have a sync speed of up to 1/500 second but the lowest ISO is 200. You may need a shutter speed higher than that to achieve a proper fill flash exposure even at your smallest aperture. The only way around this problem is to move your subject into a more shaded area. Cameras such as the D200, D2X, and D2H have a slower sync speed (1/250) but also have a lower ISO rating. These cameras also offer something called FP High Speed Sync, which enables you to shoot at speeds higher than the actual sync speed when using an SB-800 or SB-600 Nikon Speedlight featuring CLS. This is useful if you're photographing a portrait and need to use a wider aperture for less depth of field and a very high shutter

speed. The FP High Speed Sync mode causes the Speedlight to emit a series of lower power flashes that coincide with the movement of the shutter across the focal plane, which is where the digital sensor is. The drawback to FP High Speed Sync is that it diminishes the range of the Speedlight. FP High Speed Sync mode can be used all the way up the maximum shutter speed or 1/8000 second.

- Cloudy bright sunlight. This occurs when it is overcast, but you have slight shadows. This type of light is very good for photographing in. It's comparable to the light from a good softbox. All you may need to do is use your Speedlight to add a little fill-flash.
- Open shade. Open shade is defined as when your subject is in the shade but there is blue sky overhead. This situation is usually achieved by placing your subject in the shade of a building, which is a good, soft (but fairly bright) light. You can set your lighting up as you like without having to worry about too many harsh shadows from the sun.
- Closed shade. You find this type of lighting under a dense tree or under an overhang such as a veranda or porch. There aren't too many problems here caused by lighting or shadow. Set up with the lighting pattern of your choice and shoot.

Tip

When using light stands outdoors, having sandbags placed on the stands feet to prevent the wind from blowing it over is best. Sandbags are commercially available through photography stores, or you can make your own.

More outdoor photography tips are covered in Chapter 6 where I discuss action and sports photography.

Traveling with Your Wireless Studio

The first consideration you want to make when traveling with your wireless studio is getting a durable case for your equipment. Let's face it, photo gear is expensive and delicate. You don't want to stick your equipment in a suitcase and leave it to the mercy of the baggage handlers at the airport.

Camera cases and bags

A good feature about using Nikon Speedlights for your portable studio is that they are compact. They fit in almost any camera bag—and there are many types of camera bags and cases from which to choose. Depending on the size and level of protection you are looking for, you may spend hundreds of dollars to as little as 20 dollars. Here are a few different types:

- Pelican cases. These are some of the best cases you can get. Pelican cases are unbreakable, watertight, airtight, dustproof, chemical resistant, and corrosion proof. They are built to military specs and are unconditionally guaranteed forever. Pelican cases even float in salt water with a fifty-five pound load inside. A standard Pelican case that holds two camera bodies, a wide angle to medium zoom, a telephoto zoom, and two Speedlights costs about two hundred dollars. That is not a lot of money when you consider how much it would cost to replace all of that gear if it were smashed or wet.
- ◆ Shoulder bags. These are the standard camera bags you can find at any camera shop. They come in a multitude of sizes to fit almost any amount of equipment you can carry. Reputable makers include Tamrac and Lowepro. Look them up on the Web to peruse the various styles and sizes.
- Back packs. You wear these camera cases on your back just like a standard back pack. These also come in different sizes and styles. Some even offer laptop carrying capabilities. The type of back pack case I use when traveling is a NaneuPro Alpha. The design looks like a military pack, so thieves don't even know you are carrying camera equipment. When traveling, I usually pack this up with two camera bodies, a wide angle zoom, a long telephoto, three or four prime lenses, two Speedlights, a reflector disk, a twelve-inch PowerBook, and all of the plugs, batteries, and other accessories that go along with my gear. And, with all that equipment packed away, I still have space left over for a lunch. Lowepro and Tamrac also make some very excellent back packs.

Backgrounds and light stands

Although background stand kits and light stands are available with carrying cases, I find it easier to put everything in one case.

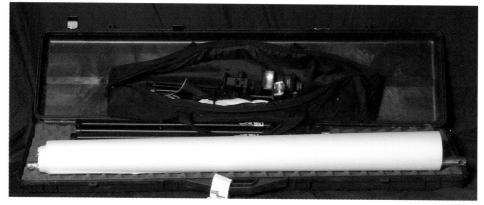

5.13 A gun case makes a great travel case for background stands and seamless backdrops. Light stands, Speedlights, and umbrellas can then be carried in the bag that the background stands originally came with.

It might sound strange, but a gun case works great for carrying two light stands, two background stands, the background cross-bar, and roll of seamless background paper cut down. Gun cases are available at sporting good stores and are relatively inexpensive. Additionally, they come in various sizes and weights—the possibilities are endless.

The hard sides keep my equipment safe, and the cases are generally lockable so no one can get into my gear without a key. It may look a bit strange, but they are a great alternative to the soft cases many stands come with, and you can carry several items in one case.

Real World Applications

ow that you've got the hang of using your Speedlight, it's time to put your skills to use in the real world. This chapter details many different kinds of photography and offers you insight on how to approach the subjects as well as tips and suggestions from real, professional experiences. Try the formulas and insight you gather here with your own flash photography for great results.

Action and Sports Photography

Action and Sports photography is just what it sounds like, although it doesn't necessarily mean your subject is engaging in some type of sport. It can be any activity that involves fast movement, such as your child riding his bike down the street or running across the beach. Shooting any type of action can be tricky to even seasoned pros. You need to be sure to shoot at a fast enough shutter speed to freeze the movement of your subject.

When shooting with a Speedlight, you're limited to using the top sync speed that your camera allows, usually around 1/250 of second, which sometimes may not be fast enough to freeze the motion. Fortunately, the flash duration is usually quick enough to freeze the motion regardless of the shutter speed. Flash duration is the length of time that flash is actually lit. When using the flash in TTL mode with the BL option turned off, the flash exposure is usually brighter than the ambient light therefore canceling out any chance of the ambient light reflecting off of the subject being recorded to the sensor and causing a motion blur.

In This Chapter

Action and sports photography

Animal and pet photography

Concert photography

Event and wedding photography

Environmental portrait photography

Group photography

Macro and close-up photography

Nature and wildlife photography

Night portrait photography

Outdoor portrait photography

Still life and product photography

Studio portrait photography

You can employ a number of different techniques to further decrease motion blur on your subject. The most commonly used technique is panning. *Panning* is following the moving subject with your camera lens. With this method, it is as if the subject is not

moving at all because your camera is moving with it at the same speed. When done correctly, the subject should be in sharp focus while the motion blurs the background. This effect is great for showing the illusion of motion in a still photograph.

6.1 Chase Hawk, Sunday's Trails, Austin TX / Nikon D70 with Nikkor 28mm f/2.8, ISO 200, and 1/500 sec. at f/4 with the built-in Speedlight set to TTL.

While panning you can sometimes use a slower shutter speed to exaggerate the effect of the background blur. Panning can be a very difficult technique to master and requires a lot of practice.

Using flash for Action/Sports photography is not always necessary or advisable. Sometimes you are so far away from the action your flash won't be effective or you may be in a situation where flash is not allowed. In these cases, just make sure you have a fast enough shutter speed to freeze the motion. You can either use a lens with a wider aperture or crank up your ISO setting to be sure you get the proper shutter speed.

Inspiration

When looking for action scenes to shoot, I tend to gravitate towards the more exciting and edgy events. On your own, just keep your eyes open, just about everywhere you look is some kind of action taking place.

Go to the local parks and schoolyards. Almost every weekend is a soccer tournament at the school across the street from my studio. I often go there just to practice getting action shots. Check your local newspapers for sporting events. Often the local skateboard shops and bike shops have contests. I try to take pictures of people having fun doing what they love to do.

Obtaining Permission

When photographing people it's usually a good idea to ask them if they mind if you take their pictures. This is especially true when photographing children. You should always find a parent or guardian and ask permission before photographing children.

Generally, I keep a pad and paper with me. I ask for a mailing address or e-mail address, and I offer to send them a copy of the photo, either in print form or as an electronic file.

If you're planning to publish your photographs, it's also a good idea to have a photo release form, also known as a model release. This document, when signed by the person you photographed, allows you to use the image at your discretion.

If your subject is under the age of 18 you must have the parent or legal guardian sign the release form

There are many sample photo release forms available on the Internet. Read them carefully to choose the right one for your photography usage.

6.2 "Pants," Ninth St. dirt jumps, Austin, TX / Nikon D200 with Nikkor 17-50 f/3.5-4.5, ISO 500, 1/30 sec. at f/4.5 with SB-600 set to TTL.

Action and sports photography practice

6.3 Flowrider competition, New Braunfels, TX / Nikon D200 with Nikkor 80-200mm f/2.8, ISO 100, 1/250 sec. at f/7.1 with SB-600 set to TTL BL.

	Ta	able	6.1	
Taking	Action	and	Sports	Pictures

Setup

Practice Picture: For figure 6.3, I had to photograph a body boarding competition. Unfortunately the sun was behind the body boarders, which would have resulted in images with the front of the subject being too dark if I didn't use flash.

On Your Own: When photographing a sporting event, if at all possible, try to keep the sun at your back so that your subject is lit from the front.

Lighting

Practice Picture: Because I had no choice other than to shoot the body boarder being backlit, I chose to use an SB-600 set to TTL BL to fill in the shadows.

On Your Own: Depending on the direction of the sun, you may or may not need to use the Nikon Balanced fill flash feature.

Lens

Practice Picture: I used a Nikkor 80-200mm f/2.8 set to 80mm to bring the action closer.

On Your Own: Depending on how close you can get to your subject, you may want to use a telephoto lens.

Table 6.1 (continued)

Camera Settings

Practice Picture: My camera was set to Shutter Priority mode to ensure that I had a fast enough shutter speed to freeze the water droplets in mid-air. Another reason I chose Shutter Priority mode was because when shooting an event such as this, the aperture setting and depth of field are secondary to getting a fast shutter speed.

On Your Own: When photographing action, setting your shutter speed is the key capturing the image properly. Whether you want to stop motion by using a fast shutter speed or blur the background using a slower shutter speed and panning with your subject, you want to be able to control the shutter speed in Shutter Priority mode.

Exposure

Practice Picture: 1/250 at f/7.1, ISO 100

On Your Own: Try to use the fastest shutter speed you can in order to stop motion. If the light is dim, you may need to bump up your ISO in order to lessen your flash output to avoid the Speedlight firing at full power and killing the batteries quickly.

Accessories

When using a lens with a long focal length, a monopod or tripod can help steady the camera resulting in sharper images.

Action and sports photography tips

- Scope out the area to find where the action is. Getting a great action shot is being at the right place at the right time. Before you break out your camera and start shooting, take some time to look around to see what's going on.
- Stay out of the way! Be sure you're not getting into anybody's way. It can be dangerous for you and the person doing the activity. Also, when shooting a sporting event, don't touch the ball! While
- shooting a baseball tournament, a foul ball rolled to my foot and I instinctively knocked it away. It cost the team a run. The coach was NOT happy with me. Luckily, they were up 14 to 1, so it wasn't a big deal, but I'll never touch another ball again!
- Practice makes perfect. Action photography is not easy. Be prepared to shoot a lot of images. After you get comfortable with the type of event you're shooting, you learn to anticipate where the action will be and you'll start getting better shots.

Animal and Pet Photography

Photographing pets is something every pet owner likes to do. I've got enough pictures of my dog to fill a three hundred gig hard drive. The most difficult aspect about pet photography is getting the animal to sit still. Whether you're doing an animal portrait or just taking some snapshots of your pet playing, your Speedlight is a handy tool.

If your pet is fairly calm and well trained, photographing them in a studio setting is entirely possible. For example, my cat, Charlie Murphy, is a pretty relaxed character who doesn't mind sitting for me on occasion.

6.4 Oregon (Golden Labrador Retriever) / Nikon D70 with Tamron 70-300mm f/4-5.6, ISO 200, 1/2500 sec. at f/4. SB-800 fired via PC sync cord in Manual mode.

Inspiration

Animals and pets are an inspiration in and of themselves. If you don't have pets your-

self, go visit a friend or relative who has one. Zoos are also a good place to find unusual animals to photograph.

6.5 Charlie Murphy mid yawn / Nikon D70 with Tokina 19-35mm f/3.5, ISO 200, 1/500 sec. at f/13 with two SB-600s shot through an umbrella.

Animal and pet photography practice

6.6 Clementine (Boston Terrier) / Nikon D200 with Nikkor 50mm f/1.8, ISO 400, 1/60 sec. at f/1.8 SB-600 on-camera TTL mode.

Table 6.2 **Taking Animal and Pet Pictures**

Setup

Practice Picture: In figure 6.6, I was trying for a portrait type shot that captured Clementine's spirit and craziness.

On Your Own: Every animal has its own personality; try to bring it out in your image. Just like when you are taking portraits of people, you want to capture the personality of the subject as much as possible.

Lighting

Practice Picture: I used an SB-600 mounted on the camera set to TTL. Red-eye reduction on the camera body set to on.

On Your Own: Because animals, especially dogs, are inquisitive, I find it easier to use the Speedlight mounted on the camera's hot shoe, or to use the built-in Speedlight. This way I can move with the pet instead of trying to persuade it to sit in one spot. When using the Speedlight on camera, be sure to use red-eye reduction to avoid the "devil-eyes."

	Table 6.2 (continued)		
Lens	Practice Picture: Nikkor 50mm f/1.8		
	On Your Own: Almost any wide-angle to short telephoto lens will do. You want to stay away from using too long of a lens because animals are usually pretty curious and always try to get close to the camera to see what it's all about.		
Camera Settings	Practice Picture: Aperture Priority, red-eye reduction on.		
	On Your Own: Use Manual or Aperture priority to control the depth of field.		
Exposure	Practice Picture: 1/60 sec. at f/1.8, ISO 400		
	On Your Own: As with portraits of humans use a wide aperture to throw the background out of focus. Set your shutter speed at or near your camera's sync speed.		
Accessories	Try using a flash mounted softbox to diffuse the light.		

Animal and pet photography tips

- Be patient! Animals aren't always the best subjects; they can be unpredictable and uncooperative. Have patience and shoot plenty of pictures, you never know what you're going to get.
- Bring some treats. Sometimes animals can be compelled to do things with a little bribe.
- Get low. Because we're used to looking down at most animals, we tend to shoot down at them. Get down low and shoot from the animal's perspective.
- Shoot wide open. If you're at a zoo and the animal is within a cage, sometimes getting close to the cage and shooting with a wide aperture can cause the cage wire to be so far out of focus that it's hardly noticeable. Using a wide aperture can also blur out distracting elements.
- Keep an eye on the background. When photographing animals at a zoo keep an eye out for cages and other things that look manmade – and avoid them. It's best to try to make the animal look like it's in the wild by finding an angle that shows foliage and other natural features.

Concert **Photography**

Doing concert photography can be both frustrating and rewarding. Sometimes to get "the" shot, you have to get in and fight a crowd, blowing your eardrums out in the process and getting drinks spilled all over your gear. Of course, if you're the type of person who likes to get into the fray, this is great fun.

Tip

I strongly suggest that you invest in good ear plugs if you plan to do much of this type of photography.

At larger venues, photographers usually are granted a spot up front from which to shoot, but usually these spots are reserved for pros on assignment and getting a media pass for these events can be next to impossible. A lot of large venues won't let the fans bring cameras in, but if you are allowed, bring a telephoto lens to get close-up shots without having to get close-up.

Some photographers are staunchly against using flash at concerts preferring to shoot with the available light. I for one prefer to use some flash as I find that sometimes the stage lights can over-saturate the performer

resulting in the loss of detail. Another downside to shooting with available light is the high ISO settings you need to use in order to get a shutter speed fast enough to stop action. Typically you need to shoot anywhere from ISO 800 to 1600 resulting in noisy images and loss of image detail.

When photographing a band or performer, you're usually in a low-light situation. Although the stage lights are bright, they're often not as bright as you need. Even when using a Speedlight, getting a fast lens in order to capture as much light as possible is best.

Lenses with faster apertures, lenses that are f/2.8 or wider, also focus faster in low-light than do slower lens or lenses that are f/3.5 or smaller. When you use a faster lens, your flash can fire at a lower power, thereby lengthening your battery life. I also recommend setting your camera at or near ISO 400. This setting also helps keep the battery consumption down while not producing an overly noisy image.

Note

Some venues or performers do not allow flash photography at all. In this situation, just use the fastest lens available and try to use the lowest ISO you can while still maintaining a fast enough shutter speed.

6.7 Duane Peters of the U.S. Bombs, the Backroom, Austin, TX / Nikon D200 with Nikkor 50mm f/1.8, ISO 640, 1/60 sec. at f/2.5. SB-600 in wireless TTL mode built-in flash as commander.

Inspiration

A good way to get your feet wet with concert photography is to find out when your favorite band or performer is playing and bring your camera. Smaller clubs are usually better places to take good close-up photos.

The key is to take pictures of what you like. Most local bands, performers, and regional touring acts don't mind having their photos taken. Offer to e-mail them some images for them to use on their Web site. This is beneficial for both them and you, as lots of people are able to see your images.

6.8 Dave Gara of Skid Row, Carlos & Charlie's, Austin, TX / Nikon D200 with Nikkor 80-200 f/2.8, ISO 800, and 1/100 sec. at f/2.8. SB-600 set to TTL BL.

Concert photography practice

6.9 Stacy Blades of L.A. Guns, the Red Eyed Fly, Austin, TX / Nikon D200 with Tokina 19-35mm f/3.5- 4.5 set at 35mm, ISO 100, 0.3 sec. at f/4.5. SB-600 in wireless TTL BL mode built-in flash as commander.

	Table 6.3 Taking Concert Pictures			
Setup	Practice Picture: For figure 6.9, I got up to the front of the stage and kneeled down to get a low perspective.			
	On Your Own: Try to find a unique perspective. Getting low always seems to make concert images more dramatic. When doing this type of shot it can be very helpful to have a friend behind you to help block the crowd.			
Lighting	Practice Picture: For this image, I set my SB-600 to wireless mode using the D200 built-in flash as the commander unit. I held the Speedlight high up in my left hand while pointing the flash-head slightly down.			
	On Your Own: Experiment with using the flash off-camera or just leave it in the camera's hot shoe.			
Lens	Practice Picture: Tokina 19-35mm f/3.5-4.5			
	On Your Own: If you're going to be getting close to the stage, a wide-angle lens is great. The perspective distortion you get with wide-angle lenses can lend a creative look to your images.			
Camera Settings	Practice Picture: My camera was set to Aperture Priority mode. Make sure you're getting as much light to the sensor as possible. When using a flash in low-light situation, the quick flash duration compensates for a slow shutter speed.			
	On Your Own: Try to use the Aperture Priority mode in low light situations. This ensures that you don't get under-exposures caused by setting your shutter speed at too high of a setting.			
Exposure	Practice Picture: ISO 100, 0.3 sec. at f/4.5			
	On Your Own: Use as low of an ISO as you can to reduce noise. Slower shutter speeds let more ambient light in resulting in a more colorful and interesting image.			
Accessories	If your camera doesn't have a built-in Speedlight that supports wireless flash and you don't have an SU-800, you can use the SC-29 TTL hot shoe sync cord for off-camera flash.			

Concert photography tips

- ★ Experiment. Don't be afraid to try different settings and long exposures. Long exposures enable you to capture much of the ambient light while freezing the subject with the short bright flash.
- Call the venue before you go. Be sure to call the venue to ensure that you are able to bring your camera in. If they do allow photography, be sure to confirm that they allow your type of equipment. I've been to an event that allowed photography, but didn't allow "prolevel" equipment. The management's idea of pro-level equipment and my idea of pro-level equipment didn't quite mesh, therefore my camera gear had to be stashed in the car.
- Bring earplugs. Protect your hearing. After spending countless of hours in clubs without hearing protection, my hearing is less than perfect. You don't want to lose your hearing. Trust me.
- Take your Speedlight off of your camera. If you have a D70/D70s, D80, or D200, use your built-in Speedlight as a commander to get the Speedlight off of your camera, or invest in an SC-29 TTL hot shoe sync cord. When you're down in the crowd, your Speedlight is very vulnerable. The shoe-mount is not the sturdiest part of the flash. Back before wireless flash, I had a couple of Speedlights broken off at the shoe, which is unpleasant to say the least. Not only is using the Speedlight off camera be safer, but also you have more control of the light direction by holding it in your hand. This reinforces the suggestion to experiment - move the Speedlight around; hold it high; hold it low; or bounce it. This is digital, and it doesn't cost a thing to experiment!

Event and Wedding Photography

Because an event is a limited occurrence, you need to be sure to capture the key moments. In a wedding, this pinnacle is usually the kiss and the cutting of the cake. For an event such as a political rally, you want to be sure to catch the keynote speaker. Events vary, so obviously, for different events you need to capture different moments.

Planning is the key to successfully photographing an event. Be sure to make a list of what you need to capture. Talk to the event planner, the bride, or the person holding the event to find out what kind of images they want. Make sure you have all the photography equipment you need for the setting, enough flash cards, and plenty of batteries for your Speedlights. That last thing you want to do is not be able to finish the job because you ran out of memory or your batteries died.

122 Part II + Creating Great Photos with the Creative Lighting System

Photographing events can be very tricky. The lighting situations are varied, people are performing random acts, and you never know what may happen. You have to keep on your toes and keep an eye open for whatever interesting situations may present themselves.

Remember that not all events—especially weddings—require traditional photography. Yes, of course, you want to provide a bride and groom the array of traditional poses, but taking many shots of the in between times can yield great images too. For example, in figure 6.10, some of the candid, photojournalistic-style wedding shots are the most charming of the day.

6.10 Morris wedding, Boerne, TX / Nikon D70 with Nikkor 28mm f/2.8, ISO 400, 1/30 sec. at f/5.6 with SB-600 set to TTL BL.

During a business party or wedding, try to take photos of people having fun and enjoying themselves. Catching the tone of the event is the essential job of the photographer.

Be sure to move around and take photos from different angles. Don't spend the whole event camped out in one spot. Talk to the people around you to put them at ease. Some folks are shy around cameras. You don't want to have nervous looking people in your pictures.

At weddings, take lots of pictures of the bride and bridesmaids getting ready and the families of the bride and groom interacting. Not only does this create a great story line for the wedding pictures later, it gets the families and wedding party used to you and your equipment. Eventually, they stop posing so much and become relaxed.

6.11 Texas Independence Day Memorial Service, Texas State Cemetery, Austin, TX / Nikon D70 with Nikkor 80-200mm f/2.8, ISO 200, 1/500 sec. at f/2.8 with SB-600 set to TTL BL.

Event and wedding photography practice

6.12 Texas Independence Day Memorial Service, Texas State Cemetery, Austin, TX / Nikon D70 with Nikkor 80-200mm f/2.8, ISO 200, 1/1600 sec. at f/3.5 with SB-600 set to TTL BL.

When photographing events indoors you may want to use a *flash bracket*. A flash bracket connects to your camera and holds the flash high and off to the side. This prevents harsh shadows from being visible,

especially when shooting indoors.

Takir	Table 6.4 ng Event and Wedding Pictures
Setup	Practice Picture: This re-enactment soldier shown in figure 6.12 was loading his musket to prepare to fire volley in honor of the soldiers who fought for Texas' Independence.
	On Your Own: Look for interesting smaller events and
	happenings going on at the larger event you're photographing.
Lighting	Practice Picture: This event took place on a bright Texas morning, so I used the sun as my main light. I used an SB-800 set to TTL BL on a flash bracket to provide some fill.
	On Your Own: If the sun is bright, use a Speedlight to fill in the shadows.
Lens	Practice Picture: Nikkor 80-200mm f/2.8
	On Your Own: When photographing an event, having a wide assortment of focal length lenses in order to be prepared for different types of shots is a good idea. For this event I had two cameras, one with an 18-70mm lens and one with an 80-200mm lens, just to be sure I wasn't caught unprepared.
Camera Settings	Practice Picture: Aperture Priority
	On Your Own: Use Aperture Priority to control your depth of field, but be prepared to switch to Shutter Priority if the action becomes fast.
Exposure	Practice Picture: 1/1600 sec. at f/3.5, ISO 200
	On Your Own: Be sure to alter your settings to fit the event. Sometimes things slow so you can use Aperture Priority, but when the action picks up you need to use Shutter Priority.

Accessories

Event and wedding photography tips

- ◆ Take lots of shots. When there is a lot of movement and action going on around you at an event, you never know what you may miss if you stop shooting during a demonstration or ceremony, for example. So, you might end up with the best picture of the day just when you were ready to put your camera down.
- Be prepared. Make sure you have everything you need. Be sure you have enough memory cards for your camera and batteries for your flash.
- Get there early. If you get there early, especially with popular events, you can get some shots of the setup, preparations, and surrounding without so many people to contend with. You can also scout out locations for events that may occur during festivals, for example, so you can find the best location to get your photos.
- Be aware. You want to catch anything interesting or pertinent to the event, so keep your eyes open.

Environmental Portrait Photography

Environmental portraits show people in their environment, which isn't necessarily in an outside setting. A typical environmental portrait may show the CEO of a corporation with his factory in the background, an author in his study, or a farmer in his field.

The best way to decide what environment to photograph your subject in is to get to know the person. Talk to your subjects to find out what they do for living or what their hobbies are. If possible, visit places of employment, worksites, and other pertinent locations to look for suitable backgrounds.

6.13 Jason Brooks, Rock of Ages Tattoo Studio, Austin, TX / Nikon D200 with Tamron 17-50mm f/2.8. ISO 100, 1/60 sec. at f/2.8 at 29mm. SB-800 set to TTL BL bounced off the ceiling. www.jasonbrookstattoo.com

Find people with interesting lines of work, such as a chef, and photograph him in his kitchen. Maybe photograph a welder or an artist standing near his or her latest piece. You can find something interesting in almost any line of work. You can also photograph someone who has an interesting

hobby as I did in figure 6.14. This gentleman participates in Texas historical re-enactments for fun.

Once again, talk to the person; he or she probably has some ideas for interesting settings as well. After all, your subject knows better than anyone what the most interesting part of his or her job is.

6.14 Texas Independence Day re-enactor, Texas State Cemetery, Austin, TX / Nikon D200 with Nikkor 18-70mm f/3.5-4.5, ISO 100, 1/250 sec. at f/4.5 with SB-800 manual setting fired via PC sync cord.

Environmental portrait photography practice

6.15 Chris, Secret Hideout Studios, Austin, TX / Nikon D70 with Tamron 70-300mm f/4-5.6 – 70mm, ISO 360, 1/10 sec. at f/4.8 with SB-600 set to TTL.

Table 6.5 **Taking Environmental Portrait Pictures**

Setup

Practice Picture: Figure 6.15 photo shows Chris, a metalworker, working on his latest project, a custom bike frame. To give a better sense of what metalworking is about, I also wanted to show some action in the shot.

On Your Own: Portraits don't have to be posed and static. When photographing environmental portraits try to show some of what the subject and the subject's interest are about — strive to put some of your subject's personality in the portrait.

Lighting

Practice Picture: I used an SB-600 held in my left hand to light the subject's face from the front while I photographed from an angle further to the right. The Speedlight was set to wireless remote and the D70's built-in flash was used as a commander. The commander flash was set to TTL.

On Your Own: Use the flash wirelessly in order to get the lighting pattern you desire on your subject.

Lens

Practice Picture: Tamron 70-300mm set to 70mm

On Your Own: Use a long telephoto lens to flatten your model's features — the further you are away from the model, the less the apparent distance from their features is. *Apparent distance* is the perceived distance things look from each other from a certain perspective. Using a wide-angle lens at close range can cause a nose to look big while also causing the ears to look too small.

Camera Settings

Practice Picture: Manual, matrix metering, slow/rear flash sync, Auto ISO. I set the camera to slow/rear flash sync to use a slower than normal shutter speed in order to catch the light trails from the sparks flying off of the grinding wheel. Although I don't normally use the Auto ISO setting, I was testing it out when I took the shot in figure 6.15. Generally, the camera sets the ISO too high for my liking, so I prefer to set the ISO manually.

On Your Own: Use the Manual or Aperture Priority settings to be able to set your aperture and control your depth of field. Matrix metering enables you use TTL BL while spot metering sets the Speedlight to TTL, which results in an overall brighter lighting pattern on your subject.

Exposure

Practice Picture: 1/10 sec. at f/4.8, ISO 360

On Your Own: Unless you need a slower shutter speed to convey some motion or action, using a shutter speed at or near the sync speed of your camera is generally advisable. Anywhere between 1/60 and 1/500 is sufficient. See your camera owner's manual for the top sync speed of your camera.

Accessories

You may want to diffuse the light from the Speedlight by bouncing from an umbrella or using a softbox.

Environmental portrait tips

- Be unconventional. Sometimes trying something out of the ordinary can really bring out your subject's personality. Think outside of the typical poses and locations. Ask to see what the subject's work involves so you can look for interesting locations or backgrounds.
- Meet with your subject first. Meet up with subjects you're photographing and talk with them about their work or hobby to get a feel for who they are. Discuss with subjects what they would like to see in the portrait; they might have some great ideas that you hadn't thought of.
- ♦ Use a shorter focal length. If you generally use a medium telephoto lens for portraits, try a shorter focal length lens instead. If you choose a wide-angle lens, don't get too close to your subject or his or her facial features may become distorted in your finished image.
- ◆ Take breaks. Giving subjects a chance to take a break allows them the opportunity to go about their work or play, which gives you the opportunity to take some shots with the subjects more at ease.

Group Photography

Group photography is basically taking pictures of multiple people, ranging from couples to entire companies. With more subjects comes more responsibility. Now, instead of having to pose one person, you have to pose multiple people. Added to that, the challenge of managing people blinking, yawning, turning their heads, and a myriad of other details.

Posing groups in attractive formations is very important—try to stay away from having them stand all in a row. Ideally, you want to position them to create a flowing pattern. Geometric patterns, such as a diamond

shape, also work well when shooting four or more people.

Depending on the circumstances and location, you may want to have a few chairs or stools handy so you can have a couple people standing behind the people that are seated.

Before you are ready to begin taking shots, make sure that you have everyone's attention. You can fire a test flash, use a whistle, or any other obvious action or noise that will garner attention. This should help to settle everyone down and let them know you're about to snap the photo, which hopefully minimizes any unwanted actions by the subjects.

6.16 © Jack Puryear, Puryear Photography / www.jackpuryear.com The Schmidt family, Leander, TX / Nikon D2X with Nikkor 17-55mm f/2.8. ISO 100, 1/250 sec. at f/8. Two SB-600 bounced with umbrellas. Flash set manually.

Family reunions and get-togethers are good place to start taking group portraits. You can find subjects at pretty much any gathering with a lot of people. Parties, nightclubs, and social events can also be great places to photograph portraits of friends, couples, and families. And, not all portraits need to be formal; sometimes capturing the spirit of the moment or gathering is as important.

6.17 Leah, Dave, English Sarah, and Leslie at the Hole in the Wall, Austin, TX / Nikon D200 with Nikkor 18-70mm f/3.5-4.5, ISO 200, 3 sec. at f/4.5 with SB-600 set to TTL BL. Camera set to rear curtain slow sync.

Group photography practice

6.18 The Addictions, taken at the former Mueller Airport, Austin, TX / Nikon D200 with Nikkor 18-70mm f/3.5-4.5. ISO 200, 1/200 sec. at f/4.5 with SB-600 set to TTL BL.

Table 6.6 Taking Group Portrait Pictures

Setup

Practice Picture: Figure 6.18 is a promotional shot I did for the Addictions, a local rock band from Austin, TX. We chose an abandoned airport that was in the process of demolition and I decided to take some shots of the group on a large pile of debris with the desolate landscape as a backdrop.

On Your Own: You can use any number of friends or relatives to achieve an effective group shot. Try to get practice in a variety of locations and with a varying number of subjects in your shots.

Lighting

Practice Picture: Because we didn't have a lot of space where we were standing and because we were so close, I opted to use an SB-800 mounted on my camera's hot shoe.

On Your Own: Depending on how large the group is and how far away you need to be from your subjects, you may need to use more than one Speedlight. For larger groups, you need more coverage, and setting up two Speedlights on either side of you is ideal.

Lens

Practice Picture: Because of my close proximity to the band, I needed to use a fairly wide-angle lens. I used the 18-70mm kit lens that is supplied with the D70 and D200. The lens was set at about 30mm.

On Your Own: Group portraits usually call for a semi wide-angle or wide-angle lens to fit more people into the frame.

Camera Settings

Practice Picture: The camera was set to aperture priority so I could control the depth of field. The camera's meter was set for spot metering so that the SB-800 would be set to TTL no BL. I did this in order to make the band stand out from the background.

On Your Own: Use the Manual or Aperture Priority settings to be able to set your aperture and control your depth of field. Matrix metering enables you use TTL BL, while spot metering sets the Speedlight to TTL, which meters only for the subject and results in an overall brighter lighting pattern on your subject.

Exposure

Practice Picture: 1/200 sec. at f/4.5, ISO 200

On Your Own: Use a lower ISO to reduce noise, and a wide aperture for shallow depth of field. You can use a shutter speed at or near the sync speed of your camera.

Accessories

You may want to use an umbrella or diffuser to soften the light.

Group portrait photography tips

- Watch for cover-ups. Before you release the shutter, be sure that no one is covering up someone else.
- ◆ Get everyone's attention. When you're about to snap the photo, let everyone know don't' surprise them or you'll end up with closed eyes and turned heads. Tell them to look at the camera. If everybody knows you're about to shoot, you have better chance at catching them with eyes open and looking directly at the camera.
- Take more than one shot. Take multiple shots to ensure that you have everyone looking in the same direction, not blinking, with hands down, etc.
- Bring an assistant. An assistant can help you keep everyone in their place and paying attention. They can also come in handy carrying equipment.

Macro and Close-up Photography

Macro and close-up are easily some of my favorite types of photography. Sometimes you can take the most mundane object and give it a completely different perspective just by moving in an varying perspective. Ordinary objects can become alien land-scapes. Insects take on a new personality when you can see the strange details of their face.

Technically macro photography can be difficult. Because the closer you get to an object, the less depth of field you get, and it can be difficult to maintain focus. When your lens is less than an inch from the face of a bug, just breathing in is sometimes enough to lose focus on the area that you want to capture. For this reason, you usually want to use the smallest aperture your camera can handle and still maintain focus. I say usually, because a shallow depth of field can also be very useful in bringing attention to a specific detail.

When using flash for macro photography, you want to get the flash as close to the axis of your lens as possible. You do this in an effort to achieve good, strong, flat lighting, which results in maximum detail. For this reason, Nikon has created a Speedlight setup designed especially for macro and close-up photography. This kit places the SB-R200 Speedlights directly on the end of the lens using a special adapter.

Taking into consideration that most people delve into photography as a hobby and don't have a real need to purchase the kit, I focus on some techniques for using the SB-600 or SB-800 for macro and close-up techniques, rather than with the kit.

While it is possible to use a Speedlight for macro photography while mounted on the camera, it doesn't always work. When shooting extremely close-up, the lens obscures the light from the flash resulting in a dark area in the images.

In order to get the flash on-axis and closer to the subject when shooting insects or other small live creatures, I use the flash in the wireless remote setting, and handhold it next to the front of the lens. I hold the Speedlight to the left of the lens (because my right hand is holding the camera). I generally angle the flash toward the subject. I sometimes hold the flash near the top of lens to achieve an overhead lighting effect.

When photographing still objects, I set up multiple Speedlights using the AS-19 stands. I place two Speedlights angled at approximately 45 degrees. Depending on how I want the image to look, I either use both of the Speedlights at their TTL settings for even lighting or I reduce the exposure compensation on one light to get a more dramatic effect.

When shooting with the Speedlight very close to the subject, I use the built-in diffuser to soften the shadows a bit. Your Speedlight will show that the power zoom level is set to 14 or 17mm, but being so close to your subject, you don't need to worry about any light fall off. You can also use bounce flash to soften the light, but I generally don't, preferring to get the most light of out of my Speedlight in order to maintain a deep depth of field.

When using the SB-800 you can use diffusion dome that is supplied with the flash. You can also purchase a diffusion dome for the SB-600. Stofen makes an inexpensive one that works very well.

6.19 Hornet / Nikon D200 with Macro-Takumar 50mm f/4. ISO 800, 1/60 sec. at f/8. Built-in Speedlight set to TTL.

My favorite subjects for macro photography are insects. I go to parks and wander around keeping my eyes open for strange bugs. Parks are also a great place to take macro pictures of flowers. Although these are the most common subjects, by no means are they the only subjects you can take pictures of. Lots of normal objects can become interesting when viewed up close.

6.20 Fence screw / Nikon D200 with Macro-Takumar 50mm f/4. ISO 400, 1/80 sec. at f/4 with the SB-600 set to TTL fired wirelessly via built-in Speedlight.

6.21 Milk drop / Nikon D70 with Nikkor 80-200 f/2.8. ISO 200, 1/500 sec. at f/20 with two SB-800's set to Manual, 1/16 power, fired via PC sync cord.

Macro and close-up photography practice

6.22 Dragonfly at Zilker Botanical Gardens, Austin, TX / Nikon D200 with Macro-Takumar 50mm f/4. ISO 100, 1/60 sec. at f/4 with the SB-600 set to TTL fired wirelessly via built-in Speedlight.

Table 6.7 **Taking Macro and Close-up Pictures**

Setup

Practice Picture: Figure 6.22 is an amazing red dragonfly I found perched on a stem while leaving the Zilker Botanical Gardens.

On Your Own: Look for subjects with bright colors and interesting texture, whether they are insects, flowers, or everyday objects.

Lighting

Practice Picture: For this shot I used an SB-600 in wireless remote using the D200 built-in flash as a commander. The commander unit was set to TTL. I held the Speedlight close to front of the lens set at a 45 degree angle.

On Your Own: When photographing a subject such as this, you want the light a little off axis, in other words angled off to the side, in order to highlight the texture.

Lens

Practice Picture: 50mm Macro-Takumar f/4. (I found this lens on eBay very cheap; it was made for old Pentax film cameras with a screw-mount.) It is manual focus, but when you're down really close to a subject, focusing is more or less achieved by moving the camera back and forth rather than focusing with the lens itself.

On Your Own: You have many different types of macro lenses from which to choose. Longer telephoto lenses let you zoom in on the subject without actually being close. Most good macro lenses are in the 50 to 60mm range allowing a closer focus and better magnification, but resulting in less depth of field.

Camera Settings

Practice Picture: The camera was set to Aperture Priority mode. Most macro subjects aren't going to move at great speeds so a fast shutter speed is not really needed. Controlling the depth of field and what is in focus is more important.

On Your Own: Set to Aperture Priority mode in order to have more control over the depth of field.

Exposure

Practice Picture: ISO 100, 1/60 sec. at f/4

On Your Own: Decide what's important in the image and focus on it. use a wide aperture to throw the background out of focus, while maintaining focus on the subject.

Accessories

If your subject is stationary, a tripod can be invaluable tool.

True Macro

Most real macro lenses are in the 50 to 60mm focal length range. True macro work is done at 1:1 perspective ratio, with the image recorded on the film or sensor being the exact same size as the actual subject. The longer focal length lenses that claim to be macro are usually 1:2, or about half size. Although they claim to be macro, they are not—they allow the illusion of macro via telephoto.

Macro and close-up photography tips

Use Close-up filters. Close-up filters are like magnifying glasses for your lenses. If you can't afford a macro lens or you're not sure if you'd use one enough to justify the expense, these filters may be the way to go. They screw directly on the front of your lens just like any other filter and can be screwed together in order to increase the magnification more. They work fairly well and are usually priced in the thirty-dollar range. Using closeup filters can soften your image a little especially when using more than one at a time.

- Try extension tubes. Adding extension tubes enables you to get a closer focus distance with your lenses. For many, this is a less expensive alternative to purchasing a dedicated macro lens. Extension tubes mount on your camera body in between the camera and the lens, an extension ring allows you to get closer to the subject by moving the lens forward thereby changing the focal range or the focusing distance of the lens.
- ◆ Consider reversing rings. These attachments allow you to attach the lens to your camera backwards which means you can focus extremely close. Think this won't work? Have you ever looked into the wrong end of a pair of binoculars? Flipping the camera lens around works the same way.

Nature and Wildlife Photography

Photographing wildlife is a fun and rewarding pastime that can also be intensely frustrating. If you know what you want to photograph it can mean standing out in the freezing cold or blazing heat for hours on end, waiting for the right animal to show up. But when you get that one shot you've been waiting for, it's well worth it.

Wildlife photography is another one of those areas of photography where people's opinions differ on whether or not you should use flash. I tend not to use flash very often to avoid scaring off the animals. But, as with any type of photography, there are circumstances in which you might want to use a flash, such as if the animal is backlit and you want some fill-flash.

Opportunities to take wildlife pictures can occur when you're out hiking in the wilderness or maybe when you're sitting out on your back porch enjoying the sunset.

With a little perseverance and luck you can get some great wildlife images just like the ones you see in *National Geographic*.

6.23 Peacock, Mayfield Park, Austin, TX / Nikon D200 with Nikkor 50mm f/1.8. ISO 320, 1/60 sec. at f/8 with the SB-600 set to TTL BL.

You can go to wildlife reserves, a zoo, or even your backyard to find "wildlife." I tend to go the easy route, going to places where I'm pretty sure to find what I'm looking for. For example, while driving through Louisiana recently, I saw a sign that for an alligator swamp tour. I was pretty sure I'd

see some alligators if I went. And even though I'd missed the last tour, there were still plenty of alligators there.

Even in the city or urban areas you may be able to find wildlife, such as birds perched on a power line. A lot of cities have larger parks where you can find squirrels or other smaller animals.

6.24 American Alligator, Irish Bayou, LA / Nikon D200 with Nikkor 80-200 f/2.8. ISO 200, 1/500 sec. at f/2.8 with the SB-600 set to TTL BL.

Nature and wildlife photography practice

6.25 Armadillo, Barton Creek Greenbelt, Austin, TX / Nikon D200 with Macro-Takumar 50mm f/4. ISO 400, 1/60 sec. at f/5.6 with the SB-600 set to TTL and fired wirelessly via built-in Speedlight.

T	Table 6.8 aking Nature and Wildlife Pictures
Setup	Practice Picture: For figure 6.25, after I discovered the armadillo, I followed it around trying to move slowly so as not to scare him off.
	On Your Own: Wild animals are generally pretty skittish (they are called "wild" for a reason) so moving slowly and trying not to make any loud noises is best.
Lighting	Practice Picture: I handheld an SB-600 and set the commander to TTL.
	On Your Own: I recommend setting the flash to TTL BL; the less you have to think about when trying not to scare an animal off, the better.
Lens	Practice Picture: Macro-Takumar 50mm f/4. I used this particular lens because I was out shooting macro shots of insects when I ran across this little guy. It was tricky, but I finally got close enough to him to snap this shot.
	On Your Own: Longer focal length lenses are usually recommended for shooting wildlife. Long lenses help you get close-up shots without disturbing the animal.
Camera Settings	Practice Picture: Aperture Priority mode
	On Your Own: Shutter Priority mode. You want to choose a fast enough shutter speed to freeze the motion of the animal in case it's moving.
Exposure	Practice Picture: 1/60 sec. at f/5.6, ISO 400
	On Your Own: Depending on how fast the animal is moving and how much light you have, you may need to adjust your ISO to achieve a faster shutter speed.
Accessories	A monopod can help you hold your camera steady when photographing animals at long focal lengths.

When photographing animals, be careful! Wild animals can be unpredictable and aggressive when cornered. Give them their space and try not to disrupt the animal's routine.

Nature and wildlife photography tips

Use a long lens. Whenever possible, use a long telephoto lens. This allows you to remain inconspicuous to the animal, enabling you to catch it acting naturally.

- Seize an opportunity. Even if you don't have the "right" lens on your camera for capturing wildlife, snap a few shots anyhow. You can always crop it later, if it isn't perfect. It's better to get the shot than not.
- Adjust your flash exposure compensation when using a long lens. The SB-600 and SB-800 zoom range only goes up to 105mm. This doesn't mean you can't use it with a lens longer than
- that. Adjusting the flash exposure compensation up can get more range out of your Speedlight. Of course, you may experience slower recycling times and shorter battery life.
- Be patient. It may take a few hours, or even a few trips, to the outdoors before you have the chance to see any wild animals. Keep the faith, it will happen eventually.

Night Portrait Photography

When photographing a portrait at night, remember that while the Speedlight is used to illuminate your subject, it is not enough to illuminate the background. In order to get enough light to allow the background to be properly exposed, you need to use a longer shutter speed. Consumer level cameras, such as the D50 and D70 have a Night Portrait setting that adjusts the camera's settings in order achieve a longer shutter speed than would normally be used when using flash. This can also be accomplished manually by setting the camera to Slow Sync mode. Slow Sync mode enables you to set a slower shutter speed when the Speedlight is attached to the camera.

When using the Speedlight in Slow Sync mode to shoot night portraits, using a tripod is almost always necessary in order to reduce the blur that is caused by handholding the camera at slow shutter speeds. Fortunately, the flash from the Speedlight is quick enough and bright enough to freeze the main subject, and so long as they don't move too much, they stay in focus with or without the tripod.

6.26 Gerald, Austin, TX / Fuji S2Pro with Nikon 24-120mm f/3.5-4.6. ISO 100, 0.7 sec. at f/3.5 with the SB-600 set to TTL BL.

Going to areas where there's a lot of nightlife can be a great place to find people to pose for portraits for you. Look for people having fun and enjoying themselves. I've never been turned down when asking someone if I could take his or her picture. Bring a pad and pencil to get an e-mail address and offer to send them a copy of the image.

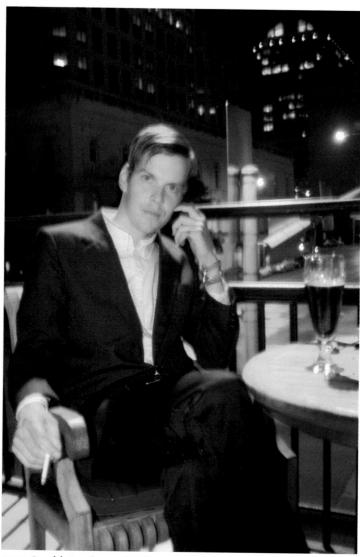

6.27 Gerald, Austin, TX / Fuji S2Pro with Nikon 24-120mm f/3.5-4.6. ISO 100, 0.7 sec. at f/3.5 with the SB-600 set to TTL BL.

Night portrait photography practice

6.28 Sky Lounge, Austin, TX / Nikon D70 with Tokina 19-35mm f/3.5-4.5 35mm. ISO 200, 2 sec. at f/7.1 with the SB-600 set to TTL BL and the camera set to Slow Sync.

	Table 6.9 Taking Night Portraits
Setup	Practice Picture: For figure 6.28, I wanted create a vivid and colorful background to accent the model's interesting makeup. I used an extra long shutter speed to ensure that the ambient lighwould show through enveloping her in a warm glow.
	On Your Own: Decide how you want the image to look before shooting and be sure to set your camera to adequately capture the image.
Lighting	Practice Picture: SB-600 mounted in the camera hot shoe. Speedlight set to TTL BL.
	On Your Own: For taking portraits at night, the Speedlight can be mounted on the camera or used off camera. When using a long shutter speed, the ambient light can soften the light from the flash allowing it to look less like a direct flash.
Lens	Practice Picture: Tokina 19-35mm f/3.5-4.5, 35mm setting
	On Your Own: When doing portraits you usually don't want to use a wide-angle lens due to the facial distortion it can cause. With the 1.5 crop factor of the D70, the 35mm setting is closer to that of a normal lens on a film camera, it works out to a 52mm lens.
Camera Settings	Practice Picture: Shutter Priority mode
	On Your Own: Use the Shutter priority mode in order to set the shutter speed slow enough to capture the ambient light.
Exposure	Practice Picture: 2 sec. at f/7.1, ISO 200
	On Your Own : Use a long enough shutter speed for the amount of light you want to let in. In this example the shutter speed was extra long, but for a more traditional look the shutter can be set a little faster—.5 sec. will do.
Accessories	When using long shutter speeds a tripod will help your subject stay in focus.

Night portrait photography tips

Bring a tripod. A tripod helps keep the camera steady for the long exposures.

- Use a higher ISO. A high ISO helps keeps the shutter speed a little faster so your subject won't be blurry.
- Find an interesting background. Look for background with some brightly colored lights to add to the ambience of the image.

Outdoor Portrait Photography

Creating portraits outdoors can mean photographing your subject anywhere from a backyard, to a park, or even a jungle. Anywhere you take portrait shots that is outdoors qualifies as an outdoor portrait.

The main difference between outdoor portraits and portraits taken indoors and studios is the use of lighting. For an outdoor portrait taken during the day, the sun, being the brightest light source, is used as your key light. Your Speedlight is used to fill in the sometimes harsh shadows created by the bright sun.

I find the best way to use the Speedlight for outdoor portraits is to set it to the Balanced Fill-Flash setting. The camera meter takes a reading of the overall brightness of the scene and use this reading to provide just enough light from the flash to fill in the shadows without looking like flash was used.

When shooting outdoors paying close attention to the way the light is falling on your subject is important. Finding a location that has good lighting and makes an attractive background is the key to a successful outdoor portrait.

6.29 Hunter, Canfield, OH / D70 with Tamron 70-300mm f/4-5.6 at 300mm. ISO 200, 1/160 sec. at f/5.6 with the built-in Speedlight set to TTL BL.

Look for areas that create interesting patterns for the background. Foliage and flowers can create nice patterns and add a splash of color. Using the beauty of nature for your backdrop can create an interesting portrait. Placing your subject in the shade of tree or building softens the light from the sun, making the lighting more even, creating a more pleasant portrait. This setting also keeps the sun out of your model's eyes so that they aren't squinting.

6.30 Rachel, South Congress, Austin, TX / Nikon D200 with Nikkor 50mm f/1.8. ISO 100, 1/320 sec. at f/4 with the SB-600 set to TTL BL.

Outdoor portrait photography practice

6.31 Ashley, Lake Travis, Austin, TX / Nikon D70 with Tamron 70-300mm f/4-5.6 at 110mm. ISO 200, 1/160 sec. at f/5.6 with the SB-600 set to TTL BL.

	Table 6.10
	Taking Outdoor Portrait Pictures
Setup	Practice Picture: Figure 6.31 was taken during a trip to the lake. The sun was going down, creating a beautiful color of light.
	On Your Own: When the sun is setting, the sky reflects the warm color on to your subject. This time is often the best to take portraits outdoors.
Lighting	Practice Picture: I used the built-in Speedlight to add some fill — because the sun was almost behind my model, she was a little backlit.
	On Your Own: Use the fill flash setting whenever your subject is backlit or if the angle of the sun is creating harsh shadows.
Lens	Practice Picture: Tamron 70-300mm f/4-5.6 set at 110mm
	On Your Own: Use a long telephoto lens to flatten your models features. The further you are away from the model the less the apparent distance from their features is. <i>Apparent distance</i> is the distance objects look from each other from a certain perspective. Using a wide-angle lens at close range can cause the nose to look big while also causing the ears to look too small.
Camera Settings	Practice Picture: Aperture Priority setting, matrix metering. I chose the AP setting in order to choose a wide aperture to throw the background out of focus. The light meter was set to matrix in order to use the Speedlight in the TTL BL mode.
	On Your Own: Use Aperture Priority to be able to set your aperture to control your depth of field.
Exposure	Practice Picture: 1/160 sec. at f/5.6, ISO 200
	On Your Own: Be sure you set your aperture so that you subject's entire face is in focus, but the background is out of focus so that the background isn't competing with your model for attention.
Accessories	A reflector of some sort can be used to fill in any deep shadows on your subject.

Outdoor portrait photography tips

- ◆ Shoot early in the morning or late in the afternoon. The sunlight when the sun is rising or setting can give your subjects a pleasing warm tone. When the sun is high in the sky during the mid-afternoon hours, the light is often harsh and can cause severe shadows.
- ◆ Use a wide aperture. Using a wide aperture creates a pleasing out of focus background. This effect is known as bokeh, pronounced bo-keh. This comes from the Japanese word "boke" which means fuzziness or dizziness.

Still Life and Product Photography

In still life and product photography, lighting is the key to making the image work. You can set a tone using creative lighting to convey the feeling of the subject. You can also use lighting to show texture, color, and form to turn a dull image into a great one.

When practicing for product shots or experimenting with a still life, the first task you need to undertake is to find something to photograph. It can be one object or a collection of objects. Remember if you are shooting a collection of objects, try to keep within a particular theme so the image has a feeling of continuity. Start by deciding which object you want to have as the main subject then place the other objects around it, paying close attention to the balance of the composition.

The background is another important consideration when photographing products or still life scenes. Having an uncluttered background in order to showcase your subject is often best, although you may want to show the particular item in a scene. An example of this would be possibly photographing a piece of fruit on a cutting board with a knife in a kitchen.

Diffused lighting is essential in this type of photography. You don't want harsh shadows making your image look like it was shot with a flash. The idea is to light it so it doesn't look as if it was lit. You want to use an umbrella or softbox to soften the shadows. If none of these are available, bouncing the flash off of the ceiling or a nearby wall can do the trick.

Even with diffusion, the shadow areas need some filling in. You can do this by using a second Speedlight as fill or by using a fill card. A *fill card* is a piece of white foam board or poster board used to bounce some light from the main light back into the shadows lightening them a bit. When using two or more Speedlights, be sure that your fill light isn't too bright, or it can cause you to have two shadows. Remember, the key to good lighting is to emulate the natural lighting of the sun.

6.32 Vintage bottle / Nikon D70 with Tamron 70-300 f/4-5.6 at 100mm. ISO 200, 1/30 sec. at f/8 with two SB-600's lighting the bottle and one SB-800 lighting the background. All Speedlights set to Manual mode.

When searching for subjects for a still life shot, try using some personal items. Objects such as jewelry or watches, a collection of trinkets you bought on vacation, or even seashells you brought home from the beach. If you're interested in cooking try photographing some dishes you prepared. Fruits and vegetables are always good subjects, especially when they have vivid colors or interesting texture.

6.33 Longhorn cheese with bread and crackers / Nikon D70 with Tamron 70-300 f/4-5.6 at 200mm. ISO 200, 1/60 sec. at f/5.6 with two SB-800's set to Manual mode fired via PC sync cord.

Still life and product photography practice

6.34 Favorite shoes / Nikon D70 with Nikkor 18-70 f/3.5-4.5 at 30mm. ISO 200, 1/500 sec. at f/11 with one SB-800 and one SB-600 both set to TTL.

Table 6.11 Taking Still Life and Product Pictures

Setup

Practice Picture: For figure 6.34, I set up an old pair of favorite shoes on grey seamless paper.

On Your Own: Keep your set simple, but still try to evoke a mood. Try to use a background that's complimentary for the color of the subject or subjects you are photographing.

Continued

	Table 6.11 (continued)
Lighting	Practice Picture: For this shot I used one SB-600 Speedlight and one SB-800. For the main light I had the SB-800 in a soft box positioned up high. For the fill I placed a second Speedlight in a soft box fairly close up on the right side. I placed the fill light close in order to use the Speedlight to fill in the dark shadows created by the main light.
	On Your Own: Make sure your light is well diffused to soften the shadows. Take a lot of test shots to see how the light is showing off the texture of your subject.
Lens	Practice Picture: Nikkor 18-70mm f/3.5-4.5 set to 30mm
	On Your Own: Use a fairly wide angle lens. Using a wide-angle lens enables you to add an interesting perspective to the subject.
Camera Settings	Practice Picture: Manual mode
	On Your Own: Manual mode or Aperture Priority mode to be able to control the depth of field.
Exposure	Practice Picture: 1/500 sec. at f/11, ISO 200
	On Your Own: Because your subject is stationary, the shutter speed isn't as much of an issue. Be sure you set your aperture so you can carry enough depth of field to ensure that everything is in focus from front to back.
Accessories	Use soft box to diffuse the light from the Speedlights.

Still life and product photography tips

- Keep it simple. Don't try to pack too many objects in your composition. Having too many objects for the eye to focus on can lead to a confusing image.
- Use items with bold colors and dynamic shapes. Bright colors and shapes can be eye-catching and add interest to your composition.
- Vary your light output. When using more than one light on the subject, use one as a fill light setting it to fire at a lower power in order to add a little depth to subject by creating subtle shadows.

Studio Portrait Photography

Shooting portraits in the studio involves more set up than other types of portrait photography. Whether your studio is in a set location or it's portable, the setup usually includes a background with stands, at least two lights with stands, umbrellas or soft-boxes, reflectors, and so forth.

Studio portraits are usually more formal than outdoor portraits, which tend to have a more relaxed feeling to them. Two major elements to remember when shooting a portrait in a studio are:

Control the background. Being able to control your background keeps distracting elements out of your image and focuses the attention where it should be, on your subject. Control the lighting. Unlike when you're shooting outdoors, in the studio you choose where the light falls on your subject, how much light is falling on your subject, and how the shadows look, by using modifiers, such as umbrellas and softboxes.

Although, studio portraits are more formal than outdoor portraits, don't be afraid to encourage your model to have fun with the shoot. You can try to make him or her laugh or suggest a few wacky poses. Also, remember that "formal" doesn't necessarily mean boring or serious. However, depending on your subject, you may find you like the more traditional, serious look.

As you do more and more portraits, you will find yourself developing a style. Almost all famous portrait photographers have their own personal style that reflects their own personality while also capturing the essence of the model.

6.35 Sara / Nikon D200 with Nikkor 80-200mm f/2.8 at 86mm. ISO 100, 1/250 sec. at f/4 with the SB-800 Set to TTL exposure compensation +1 bounced from an umbrella.

When photographing studio portraits, I often have subjects go for a more glamorous look. It's a great feeling when subjects look at a portrait you took and they are completely impressed by how beautiful or handsome they look.

Outside of practicing on family and friends, to find models for these types of shots, a great place to start is at beauty salons. Hairstylists often need pictures for their portfolios and in exchange for the photography, will often find the models and do the hair and makeup for you.

Another good source of models are actors and models who are just starting out in the business. They are often willing to trade time for prints, better known as TFP or since the advent of digital, TFCD. It's a good way to get your portfolio built up without having to pay for models.

6.36 Salon Square, Las Vegas, NV / Nikon D70 with Nikkor 80-200mm f/2.8 at 80mm. ISO 200, 1/500 sec. at f/4.5 with the SB-600 set to TTL shot through an umbrella.

Studio portrait photography practice

6.37 Montage Salon, Las Vegas, NV / Nikon D70 with Nikkor 80-200mm f/2.8 at 80mm. ISO 200, 1/500 sec. at f/5.6, with two SB-600's controlled via D70 built-in Speedlight.

Table 6.12 **Taking Studio Portrait Pictures**

Setup

Practice Picture: I set up my portable studio at the back of Salon Square in Las Vegas, NV to shoot some photographs. Figure 6.37 is just one of many I took that day.

On Your Own: As long as you have a good background (and your equipment) you can do studio portraits anywhere.

Lighting

Practice Picture: I mounted one SB-600 on a boom stand at a 60 degree angle to the model's face. The Speedlight was then bounced from an umbrella. The second SB-600 was pointed at the backdrop. The SB-600's were controlled by the D70's built-in Speedlight. Both SB-600's were set to TTL with the exposure compensation set to +2, to compensate for the light lost when bouncing from the umbrella.

On Your Own: Use one or more Speedlights to create the desired lighting pattern and mood.

Lens

Practice Picture: Nikkor 80-200mm f/2.8

On Your Own: Use a medium to long telephoto lens to enhance the model's features.

Camera Settings

Practice Picture: Manual mode

On Your Own: Use Manual or Aperture Priority mode to control

the depth of field.

Exposure

Practice Picture: 1/500 sec. at f/5.6, ISO 200

On Your Own: Set your shutter speed at or near your camera's sync speed. Using a wide aperture is not absolutely necessary when using a plain background, but it helps to let more light in so your Speedlight can fire at a lower power, giving you longer battery life.

Accessories

A fold up reflector is a great idea. As you can see in figure 6.37, you can get professional-looking portraits using only one Speedlight on the model, but you need a reflector to bounce some light into the dark side of the face.

Studio portrait photography tips

- Use a long lens. Long lenses flatten your subject's features by reducing the apparent distance, which is the distance objects look from each other from a certain perspective. For example, if you use a wide-angle lens at close range it can cause the nose to look big while also causing the ears to look too small.
- Use different color backgrounds.
 Using colors that compliment your subject's features and clothing can make a portrait stand out.

- Focus on the eyes. The most important part of a portrait is the eyes. Make sure that they are in focus. If the eyes are a little fuzzy the whole portrait looks off.
- Have a list of poses ready. Subjects often feel uncomfortable posing unless they are professional models. By having poses in mind ahead of time, it minimizes setup changes and the shoot goes smoother.
- Be ready. Once your subject is relaxed and feels comfortable, the shooting becomes easier and poses become more natural.

Simple Posing for Great Portraits

ne of the most important aspects of portrait photography is knowing how to pose your subjects. If your model looks awkward or uncomfortable, your portrait isn't going to be a success. The key to a good portrait is having the model look natural.

To be a successful portrait photographer, you need to have good technical skills, but posing subjects is an art form unto itself. As soon as you start to master the art of posing subjects, you'll find that the quality of your work will grow by leaps and bounds.

Ultimately, you need to create a set of standards that you use that works best for the types of portraits you and your clients like to see. Once you develop your own style, by sticking to your best practices, you will see great improvement in your portrait portfolio.

Posing Basics

Photographic posing isn't new; actually, posing has evolved over the centuries. Some of the best portraits I've ever seen weren't even photographs, but painted portraits dating back hundreds of years. In touring art museums here and abroad, I'm still amazed at the detail and subject matter of paintings

C H A P E R

In This Chapter

Individual posing techniques

Planning your posing

Posing basics

Positioning parts of the body

created by masters of long ago. To be fair, portrait photography has taken the art form further, some say by leaps and bounds. A little combination of both styles goes a long way.

Whether it is classic or cutting edge portraiture, some rules remain the same. Your subjects still need to seem natural and without any distortions to the person's features. You can follow a number of basic rules but don't have to adhere to them for every portrait. These rules are a great starting point for every digital portrait photographer.

Basic poses for individuals include:

- ♦ Shoulders at an angle. This is one of the first rules in portraiture. The subject's shoulders should be turned at an angle to your camera. Use this rule often, for both standing and seated situations. When the shoulders are evenly facing the photographer, the subject looks unnaturally wider. Figure 7.1 shows a simple portrait taken with the shoulders pointed at an angle to the camera. Try to ensure that the shoulder closer to the camera is lower than the other shoulder.
- Head tilted. After subjects turn their shoulders so they're on an angle, ask them to tilt and turn their head slightly so the head isn't in the same position as the shoulders. When you have your subjects tilt and turn their head slightly, you're also changing the position of the eyes, giving a more naturally interesting look to the portrait with a dynamic touch.

7.1 Pose your subjects with their shoulders pointed at an angle to the camera.

7.2 A slight tilt of the head adds drama to a portrait.

Tip

When making changes to a person's posture, try not to make the changes dramatic. Usually, just a slight turn and tilt of the head does the trick. You don't want to have the pose appear overdone.

Feet placed naturally. If you're shooting full length portraits, whether the subject is standing or sitting, make sure you pay close attention to feet. You want the feet positioned close enough together, but not un-naturally. Additionally, if your subject is facing you on an angle, place the foot closest to you angled slightly more toward the camera than the other foot. This adds more balance to the subject in some portraits, and naturally turns the subject's body more toward the camera.

Try posing your subject's feet first, and then work your way up.

After you understand some of these basic posing techniques and try them out on occasion, you're ready for the next step, which are more elaborate portrait posing techniques. I'm not talking about posing every single inch of a subject's body; just some subtle changes to posture or position can go a long way in making a great portrait.

Refined Posing Techniques

As a photographer, I consider posing an art form in itself. After I determine what type of portrait I'm photographing, I then go to work on setting up the entire body for the pose I want. I start with the feet and legs and then work my way up. Even though a small percentage of portraits are actually full-body length shots, a best-practice is to pose the subject as if their entire body is going to be included in the portrait. While you are shooting, make sure to take a few full-length shots as you may discover a few hidden gems among your images that way.

Positioning the midsection

In the real world, not all of your subjects are going to be twenty-ish models that weigh 100 pounds. Mastering techniques where you can photographically slim the midsection of your subjects is important. This is increasingly important when photographing clients who are conscious of their weight.

Establish upfront with your subject whether they want full length poses or just to be photographed from the waist up. To make subjects appear thinner, never have them pose square to the camera. For standing positions, have your subjects turn their hips toward the left or right, preferably away from the main light. You can also consider having your subjects shift their weight to the hip closest to the camera.

Other slimming techniques include:

- Legs separated slightly. In addition to having your subject turn his or her hips slightly to the left or right, you should also suggest a stance with the legs slightly separated. Avoid full-length portraits where both legs are positioned close together; keep a separation at the thighs when possible.
- Legs crossed. I use this pose quite often. Have your subject turn at an angle, either left or right (preferably toward the main light), and

shift his or her weight to the leg closest to the camera with one leg crossing the other. This creates a slight lean that looks very natural in most cases.

Clothing can also contribute to or hinder your efforts to illustrate a thinner appearance to your subject. Baggy clothing doesn't help. Be creative in those situations where your subject is wearing a pair of baggy pants, a baggy shirt, or a loose fitting dress. Have subjects lean a leg on a chair or lean on an object to thin out their appearance in the portrait when wearing baggy clothing.

Positioning the arms and hands

Working your way up, you can use a number of tips and techniques to properly position your subject's arms and hands. Using the body to make up the main composition, positioning of the arms and hands add to the desired look or style of the photograph. You want to make the person look his or her best.

Tried and true positions for the shoulders, arms, and hands include:

- Triangle pose. If you're not shooting a full-length portrait, a common technique to properly frame the portrait is the triangular pose. Try filling the bottom of the frame with your subject's arms folded, filling in the bottom of the triangle, where the arms and shoulders lead up to the triangle's peak, the person's head.
- Shoulders diagonal. Shoulders are going to be a major anchoring point for almost all of your poses. As a rule of thumb, your subject's shoulders should never be positioned

- horizontally across the frame. Have clients position their shoulders on a diagonal position to add interest to the portrait.
- One arm away from the body. To complete the body portion of your portrait, have the subject positioned with at least one arm away from his or her body to help define the midsection. Within this parameter, arms can be positioned in many ways. For waist-up portraits, having the arms leaning on a chair or other object gives a relaxed appearance to the portrait. Try having subjects shift their weight to their elbows and relax their forearms.
- Hands relaxed. Hands are often the most overlooked part of the body in portraits; however, paying attention to the detail when it comes to posing a subject adds to the quality of what you're trying to achieve. Hands are important, and you want to ensure that the subject isn't wearing any unusual bracelets or rings that can detract from your portrait. Be tactful, and ask the subject if they can remove any distracting jewelry or accessory that may not work for the portrait. Additionally, make sure the subject's fingers are straightened and relaxed. You don't want fingers curled under in a portrait.

Note

There are exceptions to every rule. Always gauge what you ask of your subjects by their personalities and what you know about them. That pinky ring may be a family heirloom or that brooch a special gift. So, use your best judgment when setting up your portraits.

Positioning the head and neck.

The final step is positioning of the head. Simple adjustments, such as having the head tilted slightly or resting on an object, can add an artistic effect to any portrait. There are actually a few decisions to make

when positioning the head, the first being what type of pose do you and your subject want for the portrait.

For me, the eyes are the most important part of any portrait. Eye contact is a focal

7.3 Sometimes looking away from the camera can create a powerful portrait.

168 Part II + Creating Great Photos with the Creative Lighting System

point where you need to ask your subjects to focus their gaze toward the camera. For some portraits, you want subjects to direct their eyes in another direction.

When taking portraits, I often have subjects try to focus their eyes in a few directions by first looking directly toward my lens, and then asking them look to the left, right, slightly up, or slightly down.

Tip

When shooting portraits either indoors or outdoors, consider adding fill flash to create a catchlight in your subject's eyes. The eyes are an important component in your overall posing, and attention to detail, such as including catchlight, adds to the quality of your portraits.

7.4 Looking up and slightly left

In addition to paying close attention to the eyes, other areas of the head are important as well. You already know about tilting the head, but you also need to consider hair posing your subjects.

For individuals with long hair, make sure you have enough room in your frame to showcase that part of the person.

7.5 Looking up and turning slightly right

7.6 Pay close attention to hair and positioning the head to where the hair is a complimentary part of the composition.

Tip

Necks often reflect weight or age of a subject. To achieve a pleasing portrait, consider either hiding portions of the neck with clothing or positioning the portrait to reduce the amount of the person's neck included. A good technique to use to reduce double chins is to have your subject slightly tip his or her head upward.

For group portrait posing tips see the section on group portraits in Chapter 6.

Positions to Avoid

When it comes to posing, there are a number of techniques to avoid, and even more techniques you need to take into consideration. A few techniques to *avoid* include:

- ◆ Try not to use the typical yearbook pose excessively. Unless you're shooting yearbook photos for a school or this is what your client wants, try to stay away from the typical head and shoulders shot. Be creative.
- ♦ Straight in front of the camera poses. This pose only works well for portraits where you want a plain look. Otherwise, the subject standing directly in front of the camera, looking straight at your digital camera is rather dull. Try to avoid poses where the person's posture is straight vertically (as in when the spine is in a perfect vertical line), or where the shoulders form a perfect horizontal line in the frame. These poses may be fine for snapshots, but not creative portraits.
- The chin too low or too high. Head positioning is very important. Make sure your portrait subject's chin isn't pointed too low to a point where the eyes aren't illuminated, and watch out for having the chin too high so that your model looks uncomfortable
- ◆ Don't instruct the person on how to pose. Show them how it's done instead. When you demonstrate to the person how to pose, he or she understand your desires much more clearly. Direct your subjects by showing not telling, and the shoot moves much quicker!

Negative body language. The last thing your portrait subjects want to see is a scowl on your face when they make a pose you don't like. You want your subjects to have a good time having their portraits taken, so always remain upbeat, positive, and constructive in the words you say and the body language you communicate.

Have some fun with your subjects – keep in mind that a successful portrait session is dependent on your subject feeling comfortable and your creativity. If you're at ease, the person you are photographing is going to be more relaxed. Encourage your subject to act natural; ask them if it's okay for you to take photos of them when they are not necessarily posed. You may end up with some photos your subject really likes and even a few for your portfolio.

Planning Poses

Before you actually start working with your subject, first determining what type of portrait you want to create is best. Are you trying to shoot a casual, traditional, or a glamour type portrait? Obviously, if you're hired by your subject, you need to find out what the client's preferences are. You may even want to try mixing things up a bit, shooting some traditional poses, photojournalistic style poses, casual poses, glamour poses, or maybe all of them. The important aspect to remember is to talk to your subject and find out what his or her expectations are. Don't be afraid to make artistic suggestions—you're the photographer after all.

7.7 Have fun while posing your models and your models will have fun too.

Casual portrait posing

A favorite type of posing is the type where you're capturing the subject just as he would be positioned in everyday life: playing the piano, watching TV, or lounging around home. The goal with casual posing

is to capture the image of the subject as if there were no posing at all.

I find the best types of casual posing are when parts of the body are positioned to allude to relaxation, such as the head resting in the hand, elbows resting on knees, the head resting on a wall or chair, or legs crossed when sitting. Any posture where the subject looks relaxed elicits a casual pose.

Traditional poses

Traditional posing is often referred to as "yearbook," or conservative posing, but it does definitely have its place in the portrait world. Many publications use these types of portraits from school publications to corporate reports. As a photographer, you are often concentrating on artistic styling, but there are many portraits in which traditional posing is more desirable and where posing is performed in a subtle manner. A conservative or traditional portrait can be used as part of a wedding album or can even be used in a photojournalistic publication.

7.8 Traditional portraits are used for purposes ranging from personal portraits to photojournalistic publications.

Traditional posing often includes these characteristics:

- Conservative expressions. Slight smiles, but not laughing is the key with traditional posing. For business publications, subjects often have more serious facial expressions.
- Plain backgrounds. For traditional portraits, plain backgrounds of a solid color, dyed, or painted muslin are commonly used.
- Seated position. Often photographers forget that people can look perfectly natural in a seated position in some cases.
- Standing position. Having subjects standing while taking traditional portraits is commonly a best practice, as the subjects are often dressed conservatively, in a suit or other more formal attire, and standing can make them feel more comfortable.

Photojournalistic poses

Photojournalists tend to take portraits while their subjects are in the midst of doing what they normally do or while they are engaged in some sort of activity. It's easier to capture someone's personality while they're taking part in some activity that they enjoy. These types of portraits are similar in feel to a casual portrait, but they are even more relaxed.

Photojournalistic poses are much less constricting than traditional posing. In other words, you and your subject can have some fun coming up with interesting poses. However, with photojournalistic style photography, you really don't have to pose your

7.9 Photojournalistic portraits often convey a sense of the subject's personality.

subjects at all. Just let them do their thing and capture their images as they would be in their natural environment. This type of portraiture is more commonly known as an environmental portrait.

For more on environmental portraits see Chapter 6.

Photojournalistic style posing has become increasingly popular in wedding photography in the past few years, and I attribute that to the advent of digital photography. Wedding photographers traditionally used standard, conservative poses; however, in the past few years, a crop of new, adventurous photographers using photojournalism techniques in their wedding work have emerged, slowly replacing the traditional posed wedding photography.

When engaged in a photojournalistic photo session, asking the client up front what his or her expectations are is best. Ask your clients to describe the types of portraits they would prefer. This information helps you request certain behavior of your clients when you're taking their portraits.

Glamour style

Glamour posing is what you expect to see on the cover of a trendy or fashion magazine or in the fashion pages within a magazine. Simply put, glamour photography is supposed to be sexy. I'm not referring to nude images; you can accomplish a sensual photograph without showing a lot of skin or any skin at all.

7.10 Glamour style portraits are considered by many as a serious art form.

Naturally, glamour photographs are used capturing images to either appeal to the opposite sex or to be used in magazines or other types of printed material to evoke a feeling of sexiness that compels consumers to buy. Just flip through a popular catalog or

a popular magazine aimed specifically at women or men, and the pages are filled with images of attractive people in sensuous poses, catering to the reader. Glamour photography is most popular in these types of media.

176 Part II ◆ Creating Great Photos with the Creative Lighting System

In addition to glamour photographs used in magazines or advertising, there is also a very large following of glamour photography as an art form. Artistically, the human form is a favorite subject for many photographers and art collectors. Creative possibilities are endless with so many different types of faces in the world to choose from. The advent of digital photography and the Web has helped bring this art form to an entire new level, allowing millions to easily view

images normally limited to art galleries or fine art photography books.

For the digital portrait photographer, thinking of glamour photography as an art form is important. When shooting glamour photographs in the studio, being professional at all times is extremely important. Make sure your models are comfortable with the types of poses they are expected to assume and invite them to participate in creating the poses.

Appendixes

PART

In This Part

Glossary

Appendix AResources

Glossary

E (Auto-Exposure) A general purpose shooting mode where the camera selects the aperture and shutter speed to its metered reading. On some cameras, the aperture, shutter, and ISO settings are automatically set.

AE/AF lock A camera setting that lets you lock the current exposure and/or autofocus setting prior to taking a photo. This button lets you recompose without holding the shutter release button half way down.

AF assist illuminator In low light and low contrast shooting conditions, the AF (autofocus) assist illuminator automatically emits a light. It is located in the front bottom of the flash. The AF-assist beam is compatible with most recent cameras, helping the Speedlight to focus its flash properly.

aperture Also referred to as the f-stop setting of the lens. The aperture controls the amount of light allowed to enter through the camera lens. The higher the f-stop numerical setting, the smaller the aperture is opened on the lens. Wider f-stop numerical settings are represented by lower numbers, such as f/2. The wider the aperture, the less depth-of-field in the image. The smaller the aperture, the more depth-of-field is in focus in the image.

aperture priority A camera setting where you choose the aperture, and the camera automatically adjusts the shutter speed according to the cameras metered readings. Aperture priority is often used for the photographer to control depth-of-field.

autofocus The ability for the Speedlight to focus correct distance to a subject as the camera lens is focused, thus supplying correct distance information to the flash.

bounce flash Pointing the flash head in an upward position or toward a wall, thus softening the light illuminated off the subject. Bouncing the light often eliminates shadows and provides a smoother light for portraits.

GL

catchlight Using the SB-800's catchlight panel while pointing the flash head straight up provides the light needed to highlight a portrait subject's eyes and a small amount of fill flash.

channel Also referred to as *communication channel*. To avoid interfering with other wireless flash users in the same vicinity, the master and slave units can communicate on one of four channels. Communications in CLS is partially based on setting the master and all additional Speedlights to the same channel. If by chance another photographer is using the same channel in the vicinity, your CLS units may fire from the other photographer's control. To avoid this, set the master and other Speedlights to a different channel.

close-up flash Close-up flash capabilities are achieved by using close-up adapters or the macro Speedlights available in the Creative Lighting System.

colored gel filters Colored translucent filters that fit over the flash head, changing the color of the light emitted on the subject. Colored gels can be used to create a colored hue of an image. Gels are often used to change the color of a white background when shooting portraits or still lifes, by placing the gel over the flash head and firing the flash at the background.

compatibility The ability of a camera, lens, or Speedlight to operate correctly when connected to one another. For example, to take advantage of all wireless lighting capabilities, the Speedlight, digital SLR, and lenses must be compatible.

contacts Electronic contacts located on the bottom of a Speedlight's shoe that makes contact with the cameras hot shoe, thus electronically connecting the Speedlight to the camera.

continuous flash The ability to use a camera's continuous shooting modes with a Speedlight and have the Speedlight fire correctly adjusted flashes with each exposure.

Creative Lighting System Also referred to as CLS, allows for multiple flash capabilities in a wireless environment, taking advantage of communication of exposure information between the camera, master flash unit, and remote Speedlights. Nikon's wireless lighting system utilizes compatible SLRs, i-TTL metering, the SB-800, SB-600, SB-200, SU-800 Commander, and the SBR-200 Macro Speedlights.

custom functions and settings The ability to customize Speedlight features and settings. Custom functions and settings can be made on both the Speedlight(s) and the camera, depending on the functionality desired.

D-type lenses Nikon D-type lenses send distance information to the camera body and allow for aperture settings to be made either by the camera or on the aperture lens ring. See also G-type lenses.

default settings Factory settings of the Speedlight. When connecting your Speedlight to your camera, the Speedlight works automatically while in auto, aperture, shutter priority, or program modes.

digital SLR Single lens reflex camera with interchangeable lenses and an image sensor.

exposure compensation The ability to take correctly exposed images by letting you adjust the exposure, typically in 1/3 stops from the metered reading of the camera. Enables the photographer to make manual adjustments to achieve desired results.

exposure mode Camera settings that let the photographer take photos in automatic mode, shutter priority mode, aperture priority mode, and manual mode. When set to aperture priority, the shutter speed is automatically set according to the chosen aperture (f-stop) setting. In shutter priority mode, the aperture is automatically set according to the chosen shutter speed. When using manual mode, both aperture and shutter speeds are set by the photographer, bypassing the cameras metered reading. When using automatic mode, the camera selects the aperture and shutter speed. Some cameras also offer Scene modes, which are automatic modes that adjust the settings to pre-determined parameters, such as a wide aperture for the portrait scene mode and high shutter speed for sports scene mode.

fill flash A lighting technique where the Speedlight provides enough light to illuminate the subject in order to eliminate shadows. Using a flash for outdoor portraits often brightens up the subject in conditions where the camera's meters light from a broader scene.

flash An external light source that produces an almost instant flash of light in order to illuminate a scene. Your Nikon Speedlight is a flash.

flash button A button on the rear panel of the Speedlight used to test fire the flash.

flash color information communication

Color temperature information is automatically transmitted to the camera, providing the camera the correct white balance setting, giving you accurate color in your image when shooting photos with a Speedlight.

flash exposure compensation Adjusting the flash output by +/-3 stops in 1/3 stop

increments. If images are too dark (underexposed), use flash exposure compensation to increase the flash output. If images are too bright (overexposed), you can use flash exposure compensation to reduce the flash output.

flash head The part of the Speedlight that houses the flash tube that fires when taking a flash photo. Flash heads can be adjusted for position. See flash head tilting.

flash head rotating lock release Buttons located on the left and right side of the flash head, that when pressed, enables you to adjust the position of the flash head horizontally or vertically.

flash head tilting Adjusting the flash head horizontally or vertically by pressing the tilting/rotating lock release button and repositioning the flash head. Often used to point the flash in an upward position when using bounce flash. Tilt the flash head straight up toward the ceiling when using the catch light panel.

flash modes Obtaining correct flash exposure when the Speedlight measures flash illumination from the subject, combining the camera's lens, ISO, aperture and shutter speed values. Flash modes include Auto Aperture, non-TTL automatic mode, and Manual mode.

flash output level The output level of the flash as determined by one of the flash modes used. If using Manual mode, proper guide numbers need to be calculated in order to provide the correct amount of illumination.

flash shooting distance and range The actual range that the Speedlight has the ability to properly illuminate a subject. The range, typically between 2 to 60 feet, is

dependent on the ISO sensitivity, aperture setting and zoom head position.

flash sync mode Set in conjunction with camera settings, flash photos can be taken in either front curtain or rear curtain sync. For most flash photos, the default is front curtain sync. When using front-curtain sync, the flash fires right after the shutter opens completely. In rear-curtain sync, the flash fires just before the shutter begins to close. Use rear-curtain sync in low light situations to avoid unnatural looking photos that occur due to subject movement.

FV lock The FV lock allows you to meter the subject to obtain the correct flash exposure, then lock the settings by pressing the FV lock button. You can then recompose the shot, usually with the subject to one side or the other, and take the photograph with the camera not metering for the new composition, thus retaining the proper flash exposure for the subject.

G-type lenses Nikon G-type lenses differ from D-type (see D-type lenses) in that they do not have an aperture ring. G-type lenses are designed for cameras where aperture is set by the camera and do not work on older SLRs.

Group When using wireless flash, Speedlights can be arranged in groups, where each group shares the same flash output setting controlled by the master flash unit.

Guide number Indicates the amount of light illuminated from the flash. Each model Speedlight has its own guide number, indicating the Speedlight's flash capability based on its maximum capability. The guide number is calculated based on an ISO setting,

flash head zoom position, and distance to the subject.

hot shoe Slot located on the top of the camera where the Speedlight connects. The hot shoe is considered "hot" because of its electronic contacts that allow communication between the Speedlight and the camera.

ISO sensitivity The ISO (International Organization for Standardization) setting on the camera indicates the light sensitivity setting. Film cameras need to be set to the film ISO speed being used (such as ISO 100, 200, or 400 film), where digital cameras ISO setting can be set to any available setting. In digital cameras, lower ISO settings provide better quality images with less image noise, however the lower the ISO setting, the more exposure time is needed.

i-TTL Nikon latest flash metering system. This system uses pre-flashes along with information from the 3D color matrix metering to determine the proper flash exposure value.

manual exposure Bypassing the camera's internal light meter settings in favor of setting the shutter and aperture manually. Manual exposure is beneficial in difficult lighting situations where the camera's meter does not provide correct results. Switching to manual settings could entail a "trial and error" process until the correct exposure is reviewed on the digital cameras LCD after a series of photos are taken. When using film cameras, there is no capability of reviewing images after they are taken.

Manual mode Manually setting the flash output of the Speedlight independently from the calculated exposure of the camera.

master When using multiple Speedlights in a wireless flash configuration, the master flash unit is the one mounted on the camera. It controls the flash output of all remote units. The built-in Speedlights of some camera models can also act as a master flash. The master flash unit is also sometimes called a commander. See also *remote*.

metering Measuring the amount of light utilizing the camera's internal light meter. For most flash uses, Speedlights emit a preflash for the camera's light meter in order to achieve a properly exposed photo.

minimum recycling time The shortest amount of time a Speedlight needs to be able to properly fire a flash after a previous flash was fired. Speedlights are powered by batteries, and the minimum recycling time is a specification used to indicate how long it takes your Speedlight to recharge between photos.

Mode button The button on the Speedlight that changes the setting for operation.

modeling light A secondary light, usually tungsten or halogen, built into a studio strobe in order visualize what the flash will look like. Some Nikon Speedlights, such as the SB-800 have a modeling illuminator feature that fires a short burst of rapid flashes that allow you to see what the flash will look like. The SB-600 can use the modeling illuminator feature when used with certain camera bodies such as the D200.

mounting foot lock lever The lever located on the rear side of the Speedlight that when moved to the right, locks the Speedlight to the camera's hot shoe.

multiple flash Using multiple Speedlights, wired or wirelessly in conjunction to illuminate a subject. Allows the photographer to create natural-looking photographs by creatively placing multiple flashes in different positions (and flash output) to achieve the desired lighting results.

Nikon autofocus Speedlight Refers to any Nikon model Speedlight that automatically adjusts the zoom range to match the focal length of the lens. The SB-800 and SB-600 are autofocus Speedlights, while the SBR-200 is not.

Nikon camera groups Nikon SLR cameras are divided into different camera groups, each with its own TTL, i-TTL, and Creative Lighting System compatibilities. The Creative Lighting System is new, and many older film and digital SLR models are not fully compatible. For an updated list of CLS compatible Nikon SLRs, refer to http://nikonusa.com.

Nikon D-TTL mode An older Nikon through-the-lens metering system used on the D1 series cameras and the D100 DSLR.

non-CPU lenses Older lenses that do not communicate electronically with the camera. These lenses are not compatible with wireless lighting systems; however, these lenses can be used in other Manual mode configurations.

On/Off button The button located on the rear panel of the Speedlight that when turned on, powers up the Speedlight.

power zoom function When using compatible cameras and Speedlights, the ability for the Speedlights flash head to automatically zoom to the focused subject.

Programmed auto (P) When using a Speedlight with a compatible camera set to Programmed auto the shutter speed is automatically set to the camera's sync shutter speed when using flash. On the camera, the shutter speed and aperture are automatically made when the subject is focused.

ready light Located on the rear panel of the Speedlight, the ready light indicates that the flash is ready to fire.

rear-curtain sync Setting the Nikon camera to rear curtain sync causes the flash to fire right before the shutter closes.

red-eye reduction A flash mode controlled by a camera setting that is used to prevent the subject's eyes from appearing red in color. The Speedlight fires multiple flashes just before the shutter is opened. As a general rule, the further the flash head is located from the camera lens, the less chance of getting the red-eye effect. You can combine red-eye reduction with slow-sync in low light situations.

remote A Speedlight used in a multiple flash configuration that is not attached to the camera. The Speedlight attached to the camera is called a master, where all the other Speedlights are referred to as remotes, or slaves. See also *master*.

reset Pressing the Mode and On/Off buttons simultaneously for about 2 seconds on the Speedlight resets the Speedlight settings to their default values.

Shutter Priority In this camera mode, you set the desired shutter speed, and the camera automatically sets the aperture setting for you. Best used when shooting action shots to freeze motion of the subject using fast shutter speeds.

slave See remote.

sound monitor Remote Speedlights automatically emit a beep after they have been remotely fired and are recharged and ready to fire again. This sound can be turned off. The Speedlight also emits a series of beeps if the flash output isn't sufficient to illuminate the subject.

standby function The Speedlights ability to automatically switch to a sleep mode if the Speedlight is not used for a pre-determined period of time. The standby function prevents a rapid degradation of the Speedlights batteries. You can return the Speedlight to normal ready mode by pressing the shutter button half-way on the camera.

TTL mode Stands for through-the-lens. This metering mode allows for automatic flash output calculated by the camera's ability to communicate flash output levels to the Speedlight per the cameras metered reading.

underexposure value The amount of underexposure set on the Speedlight (using exposure compensation) and indicated on the Speedlight's LCD panel.

wireless remote flash unit See remote.

zoom head Also referred to as the Speedlight's flash head that has the capability of automatically moving the flash tube forward or backward during automatic flash operations to match the focal length of the lens being used.

Resources

here is a lot of valuable information available on the Internet for photographers. This appendix is a resource to help you discover some of the many ways to learn more about the Nikon Creative Lighting System and about photography in general.

Informational Web Sites

With the amount of information on the Web, sometimes it is difficult to know where to look or where to begin. These are a few sites that I suggest you start with when looking for reliable information about your CLS or photography in general.

Nikon

When you want to access the technical specifications for Nikon Speedlights, cameras or lenses visit the Nikon Web site http://nikonusa.com.

Nikonians.org

This site is a forum where you can post questions and discussion topics for other Nikon users on a range of photography-related topics. Find it at www.nikonians.org.

Photo.net

The Photo.net site, at http://photo.net, is a large site containing resources from equipment reviews, to forums on a variety of topics, to tutorials, and more. If you are looking for specific photography-related information and aren't sure where to look, this is a great place to start.

Workshops

There are a multitude of different workshops that offer training for photographers. Here is a list of some of the different workshops that are available to you.

Anderson Ranch Arts Center

www.andersonranch.org

Ansel Adams Gallery Workshops

www.anseladams.com

Brooks Institute Weekend Workshops

http://workshops.brooks.edu

Mentor Series

www.mentorseries.com

Missouri Photo Workshop

www.mophotoworkshop.org

Mountain Workshops

www.mountainworkshops.org

Palm Beach Photographic Centre Workshops

www.workshop.org

Photography at the Summit

 $\verb|http://photographyatthesummit.com| \\$

Rocky Mountain Photo Adventures

www.rockymountainphoto adventures.com

Santa Fe Workshops

www.santafeworkshops.com

The Workshops

www.theworkshops.com

Online Photography Magazines and Other Resources

Some photography magazines also have Web sites that offer photography articles and often information that isn't even found in the pages of the magazine. The following is a list of a few photography magazines' Web sites as well as some other photo related sites where you may find useful content.

Communication Arts

www.commarts.com/ca/

Digital Photo Pro

www.digitalphotopro.com

Digital Photographer

www.digiphotomag.com

Flickr

www.flickr.com

Ken Rockwell

www.kenrockwell.com

Outdoor Photographer

www.outdoorphotographer.com

Photo District News

www.pdnonline.com

Popular Photography & Imaging

http://popphoto.com

Shutterbug

www.shutterbug.net

Index

Symbols & Numbers	Alpha (NaneuPro), 104
+/- buttons, 22	ambient lighting, 56
3D balanced fill-flash, 32	Anderson Ranch Arts Center, 186
BD Multi Sensor metering. See TTL	animal photography
metering system	discussed, 113
metering system	inspiration for, 113
A	practice exercises for, 115–116
AA batteries, 29, 50	tips for, 116
AA flash mode. <i>See</i> Auto Aperture flash	Ansel Adams Gallery Workshops, 186
mode	aperture
accessories	exposure specifications for, 71, 73
availability of, 52	for low light situations, 117
lighting, 52	wide, 152
for power, 17	architectural photography, 75
for SB-600, 23	arms, posing for, 166
for SB-800, 17	art photography, 174–176
action photography	AS-19 Speedlight stand
discussed, 107–109	for SB-600, 23
inspiration for, 109	in SB-800, 17
lighting for, 75	for still objects, 136
permission release for, 109	Auto Aperture (AA) flash mode
practice exercises for, 111–112	availability of, 24
shutter speed for, 109	button for, 16
tips for, 112	discussed, 32
wireless Speedlights for, 75	exposure with, 77
advanced wireless lighting	in SB-800, 16
discussed, 10	using, 32
in SB-800, 11	auto FP high-speed sync, 25
AF Assist function	automatic non-TTL flash, 14
for dark environments, 44	automatic white balance, 64
in SB-600, 44	automatic zooming flash-head
in SB-800, 11, 14, 45	in SB-600, 18
setup for, 44–45	in SB-800, 10
AF-assist contacts, 15	
AF-assist illuminator (AF-ILL)	В
in SB-600, 18, 19, 44	back packs, 104
in SB-800, 45	background(s)
wide-area, 10, 24, 25	in animal and pet photography, 116
alkaline-manganese batteries, 30	canvas backdrops, 94
<u> </u>	Continued

Index **→** B**−**C

background(s) (continued)	settings for, 69–70
controlling, 157	for still life and product photography, 153
discussed, 92	using, 67–69
interesting, 148	bounced lighting, 56
muslin backdrops, 93–94	bright sunlight, 102–103
plain, 173	broad lighting, 56
for portable studio, 92–95	Brooks Institute Weekend Workshops, 186
seamless paper backdrops, 92–93	built-in Speedlight
stands for, 95	channel setting on, 82
for still life and product photography, 153	for concert photography, 121
traveling with, 104–105	for D200, 85
background light, 77	output level compensation settings for,
backwards-compatibility, 31	85–86
balanced fill (BL) flash. See also TTL BL flash	setup for, 81
3D, 32	business events. See event photography
discussed, 32	butterfly (Hollywood glamour) lighting, 96
for outdoor portrait photography, 149	button. See specific types, e.g.: multi-selector
batteries	button
AA, 29, 50	
alkaline-manganese, 30	C
lithium, 30	camera
nickel, 30	adjusting output compensation on, 38
nickel metal hydride, 30–31	flash setup in, 76–78
nickel-cadmium, 30	camera cases/bags, 103–104
non-rechargable, 30	camera compatibility
Quick Recycling Battery Pack and, 31	backwards-compatibility, 31
rechargeable, 29, 30–31	of camera bodies, 23–26
SB-800, 31	for CLS, 76
types of, 30	canvas backdrops, 94
battery compartment lid	casual posing, 172–173
in SB-600, 18	catchlight (bounce) card (SB-800), 14
in SB-800, 13	channel setting
BL (balanced fill) flash mode. See also TTL	on built-in Speedlight, 82
BL flash	choosing, 77
3D, 32	on SB-800, 82
discussed, 32	setup for, 37
for outdoor portrait photography, 149	for wireless flash photography, 82–83
blur, 108, 109	on wireless remote flash, 82–83
body language, negative, 171	chin, posing of, 170
bokeh, 152	closed shade, 103
bounce (catchlight) card (SB-800), 14	close-up filters, 140
bounce flash	close-up photography
discussed, 66–69	at concerts, 118
distance for, 67	discussed, 135–136
in SB-600, 18	focal length for, 135, 140
in SB-800, 11	inspiration for, 137
,	p ac

practice exercises for, 139	D
tips for, 140	D2H/D2H
clothing, affecting posing, 166	Speedlight use in, 26
cloudy bright sunlight, 103	wireless Speedlights for, 77
CLS. See Nikon Creative Lighting System	D2X/D2XS
color temperature	features of, 25
automatic white balance for, 64	Speedlight use in, 26
control of, 65	wireless Speedlights for, 77
cool, 62, 64	D50 camera
discussed, 62	features of, 24
Kelvin and, 62	wireless Speedlights for, 77
preset white balance and, 62, 64-65	D70/D70S
in SB-600, 10	adjusting output compensation
in SB-800, 10	on, 39
warm, 64	built-in Speedlight for, 85
commander unit flash. See Master unit flash	features of, 24
Communication Arts, 186	ISO of, 102
compatibility	
backwards-compatibility, 31	ISO settings of, 102 as Master (commander) unit, 78–79
of camera bodies, 23–26	Speedlight use in, 25–26, 78
for CLS, 76	sync speed in, 73, 102
compensation settings. See output level	D200
compensation settings	
concert photography	adjusting output compensation
discussed, 117	on, 40
inspiration for, 118	built-in Speedlight for, 85
ISO for, 117	features of, 24–25
light issues with, 117	as Master (commander) unit, 78–79
practice exercises for, 120	product photography with, 102
tips for, 121	Speedlight use in, 26, 78
conservative expressions, 173	dark environments, lighting for
conservative posing, 171, 173	aperture for, 117
contrast reduction, 61	using AF Assist, 44
control buttons	using fill flash, 61
of SB-600, 20, 21–23	deflectors, 60
of SB-800, 14, 15–17	diffused lighting, 56, 90, 153
convertible umbrella, 89	diffusers, 60
"cool" colors, 62, 64	diffusion dome, 136
Creative Lighting System. See Nikon Creative	diffusion panel, 91
Lighting System	Digital Photo Pro, 186
cross-bar, 95	Digital Photographer, 186
(2)	dimensional lighting settings. See Group
custom settings mode (CSM)	settings
+/- buttons for, 22	directional light
for channel settings, 37, 79	discussed, 54
in SB-600, 22	from umbrellas, 89
cycling modes, 31	

distance	fill flash
affecting exposure specifications, 71, 73	contrast reduction using, 61
for bounce flash, 67	for dark environments, 61
from subject, 67	exposure specifications for, 73–74
distance-priority manual flash mode	manually setting, 73–74
availability of, 24, 25	outdoors, 60
in SB-800, 11	fill light, 60, 77
down button (SB-800), 15	flash
DTTL flash mode, 31	
DTTL metering, 31	3D balanced fill-flash, 32
DITE metering, 31	automatic non-TTL flash, 14
E	balanced fill (BL) flash, 32, 149
environmental portrait photography	bounce, 67–69
	bounce flash, 11, 18, 66–70, 153
discussed, 126	at concerts, 117
focal length for, 131	duration of, 107
inspiration for, 128	fill flash, 60, 61, 73–74
practice exercises for, 130	modeling, 11
tips for, 131	modeling flash, 11, 18
event photography	non-TTL, 14, 24, 25, 33
discussed, 121–122	remote flash, 34–35, 82–83, 87
inspiration for, 123	flash button
practice exercises for, 125	in SB-600, 22
tips for, 126	in SB-800, 16
exposure	flash color information, 10
aperture affecting, 71	flash head
discussed, 70	automatic zoom with, 10, 18
distance affecting, 71, 73	positioning, 69
experimenting with, 121	in SB-600, 18
fill flash affecting, 73–74	in SB-800, 10, 12
Guide Number (GN) and, 70–73	flash head lock release button
with long lenses, 145	in SB-600 Speedlight, 18
modes for, 69	in SB-800, 13
setting, 69	flash head tilting/rotating angle scale
sync speed affecting, 73	in SB-600, 19, 21
expressions, conservative, 173	for SB-800, 14, 15
extension tubes, 140	flash head zoom, 5
external AF-assist contacts	flash modes, 31–34
in SB-600, 21	Auto Aperture (AA), 32
for SB-800, 15	availability of, 22
external power source terminal	balanced fill (BL), 32
(SB-800), 14	choosing, 77
eye contact, 162, 167–169	distance-priority, 11
0,0 00maci, 102, 101 100	DTTL, 31
F	
feet, posing of, 165	Guide Number for, 33 i-TTL, 31
fill card, 153	manual, 11, 32
1111 CUI U, 100	illallual, 11, 34

non-TTL Auto flash, 14, 24, 25, 33	G
repeating, 11	glamour style art photography,
repeating flash, 33–34	174–176
in SB-600, 22	glamour style posing, 174–176
in SB-800, 11	GN. See Guide Number
setting, 69	group photography
setup for, 80–81	discussed, 131
TTL, 32	inspiration for, 132
for wireless flash photography,	practice exercises for, 134
80–81	tips for, 135
flash mount softboxes, 90	•
flash photography. See also wireless	group settings discussed, 77, 83–84
flash photography	
color temperature and, 62–65	setup for, 37
discussed, 49	using SB-600, 84
exposure for, 70	using SB-800, 84
lighting basics for, 53–61	for wireless flash photography,
method comparisons, 49–53	83–84
settings for, 69–70	Guide Number (GN)
specifications for, 70–74	button for, 16
with Speedlight, 49–53	defined, 32
with studio strobes, 49–53	discussed, 11
using bounce flash, 66–69	distance priority mode, 33
white balance and, 62–65	exposure specifications with, 70–73
flash value (FV) lock	for flash, 33
availability of, 24, 25	ISO sensitivity and, 70
	for mode button, 32
discussed, 10	in SB-600, 17, 18, 71
in SB-800, 11	in SB-800, 10, 11, 16, 72
flash-mount softboxes, 90	gun cases, 104–105
Flickr Pro, 186	***
focal length	H
for environmental portraits, 131	hair, posing issues with, 169–170
for macro and close-up photography,	hands, posing for, 166
135, 140	head, posing of, 164, 167–170
for portrait photography, 131	high-speed sync, 10
space requirements for, 96	Hollywood glamour (butterfly) lighting, 96
focal range, 140	hot shoe mounting foot
FP high-speed sync	in SB-600, 21
auto, 25	for SB-800, 15
for bright sunlight situations,	umbrellas and, 89
102–103	hotspot, 90
drawbacks of, 103	
in SB-600 Speedlight, 18	I
in SB-800, 11	illumination. See lighting
frontal lighting, 56	indoor portrait photography, 149
FV (flash value) lock, 10	

Index **→** I—M

indoor studios	color temperature of, 62–65
discussed, 95	controlling, 157
outdoor photography vs., 149	for dimensionality, 37
for portraits, 95–96	direction of, 54
setup for, 95–96	evenly, 69
space requirements for, 95–96, 102	loss of, 70, 90
informational web sites, 186	outdoor lighting, 60–61
Inverse Squire Law, 71	outdoors, 60–61
ISO settings	portability of, 50
for concert photography, 117	settings for, 69–70
of D70/D70S, 102	situations, common, 102-103
Guide Number and, 11	in studio, 53–60
high, 102	studio lighting, 53–60
i-TTL balanced fill flash. See TTL BL flash	traveling with, 49
i-TTL flash. <i>See</i> TTL flash	varying, 156
i-TTL metering. See TTL metering system	lighting ratios, 59
15	lithium batteries, 30
K	locking controls, 41
Kelvin scale, 62	loop (paramount) lighting, 96
Ken Rockwell, 186	low-light situations
	aperture for, 117
L	using AF Assist, 44
LCD panel	using fill flash, 61
illumination of, 45	
in SB-600, 19	M
for SB-800, 14	M flash mode. See manual flash mode
setup for, 45	macro photography
testing shots and, 70	discussed, 135–136
LED, for wide-area AF-assist illuminator, 10	focal length for, 140
left button (SB-800), 16	inspiration for, 137
legs, posing for, 165–166	outdoor portrait photography, 135
lens adapter, wide-angle, 20	practice exercises for, 139
light deflectors, 60	tips for, 140
light diffusers, 60	"true," 140
light sensor	main light, 77
for automatic non-TTL flash, 14	main parts
in SB-600, 18	of SB-600, 18–21
in SB-800, 14	of SB-800, 12–15
for TTL wireless flash, 14, 18	manual (M) flash mode
light stands, traveling with, 104–105	button for, 16
lighting, 53–61. See also specific types, e.g.:	discussed, 22, 32, 77
bounced lighting	distance-priority, 11, 24, 25
accessories for, 52	in SB-800, 16
advanced wireless, 10	Master (commander) unit flash
amount of, 55	adjusting output compensation with, 39
with bounce flash, 66–69	choosing, 78

D70/D70S as, 78-79	neck, posing of, 167–170
D200 as, 78–79	negative body language, 171
defined, 34	NiCd (nickel-cadmium) batteries, 30
SB-800 as, 78–79, 80–82	nickel batteries, 30
SB-800 Speedlight as, 40	nickel metal hydride (ni-MH) batteries,
setup for, 34, 78–79	30–31
SU-800 commander unit in, 40	nickel-cadmium (NiCd) batteries, 30
for wireless flash photography, 78–79	night portrait photography
Mentor Series, 186	discussed, 145
midsection, posing for, 165–166	inspiration for, 146
minus button. See also +/- buttons	practice exercises for, 148
mode button and, 23	slow sync for, 145
in SB-600, 23	tips for, 148
zoom button and, 23	Nikon (Web site), 185
Missouri Photo Workshop, 186	Nikon Creative Lighting System (CLS)
mode button	camera compatibility for, 23–26, 76
cycling modes in, 31	as communication device, 76
Guide Number for, 32	components of, 9
	discussed, 9, 23
minus button and, 23	features of, 9–10
on/off button and, 17, 22	SB-600, 17–23
in SB-600, 22, 23	SB-800, 10–17
in SB-800, 16, 17	SBR-200 Speedlight for, 27
select button and, 17	
zoom button and, 22	SU-800 commander unit for, 26
modeling flash	wireless flash photography with, 76–78
in SB-600 Speedlight, 18	nikonians.org, 185
in SB-800, 11	ni-MH (nickel metal hydride) batteries, 30–31
modeling lights, 52	non-CLS cameras, 31
motion blur, 108, 109	non-rechargable batteries, 30
Mountain Workshops, 186	non-TTL Auto flash mode
mounting foot locking lever	availability of, 24, 25
in SB-600, 20	discussed, 14, 33
for SB-800, 14	light sensor for, 14
multiple-flash terminal, 14	using, 33
multi-selector button (SB-800), 15	0
muslin backdrops, 93–94	0
	off button. See on/off button
N	online photography magazines, 186–187
NaneuPro Alpha, 104	on/off button
natural lighting, 56	mode button and, 17, 22
nature photography	in SB-600, 22
discussed, 140–141	in SB-800, 16, 17
inspiration for, 142	select button and, 17
lighting for, 60	open shade, 103
practice exercises for, 144	outdoor lighting, 60–61
tips for, 144–145	Outdoor Photographer, 187

196 Index + O-P

outdoor portrait photography	environmental portrait, 126–131
discussed, 149	event, 121–126
indoor photography vs., 149	group, 131–135
inspiration for, 150	macro, 135–140
lighting for, 60	nature, 140–145
practice exercises for, 152	night portrait, 145–148
SB-600 Speedlight for, 102	outdoor portrait, 149–152
SB-800 Speedlight, 102	pet, 113–116
tips for, 152	product, 153–157
outdoor studio, 102–103	sports, 107–112
output level compensation settings	still life, 153–157
adjusting, 38–40, 78	studio portrait, 157–162
for built-in Speedlight, 85–86	wedding, 121–126
for camera, 38	wildlife, 140–145
on D70/D70S, 39	photojournalistic posing, 173–174
on D200, 40	Photo.net, 185
for SB-800, 84–85	placement. See posing
setup for, 38–40	placement, of studio lighting, 53–56
on SU-800, 40	plain backgrounds, 173
for wireless cameras, 39-40	planning
for wireless flash photography, 84–86	for event photography, 121
_	for posing, 171–176
P	+/- buttons (SB-600), 22
Palm Beach Photographic Centre	Popular Photography & Imaging, 187
Workshops, 186	portability, of lighting, 50
panning, 108, 109	portable studio
paper backdrops, seamless, 92–93	backgrounds for, 92–95
paramount (loop) lighting, 96	discussed, 87–88
patience, 116	lighting for, 49
PC sync terminal (SB-800), 15	needs of, 88
pelican cases, 104	softboxes for, 90–92
permission release, 109	space requirements for, 95–96, 102–103
pet photography	traveling with, 103–105
discussed, 113	umbrellas for, 88–90
inspiration for, 113	portrait photography
practice exercises for, 115–116	environmental, 126–131
tips for, 116	focal length for, 131
Photo District News, 187	full length, 89
photo release forms, 109	indoor, 95–96
Photography at the Summit, 186	lighting for, 37, 56, 75, 96
photography types/styles	at night, 145–148
action, 107–112	outdoor, 149–152
animal, 113–116	setup for, 95–96
close-up, 135–140	in studio, 157–162
concert, 117–121	umbrellas for, 89
discussed, 107	wireless Speedlights for, 75–77

posing	RAW conversion software, 65
of arms and hands, 166	RAW mode, 65
basic techniques for, 164–165	ready light
casual, 172–173	in SB-600, 20
discussed, 163	for SB-800, 14
glamour style, 174–176	real-world applications
of groups, 131–135	for action photography, 107–112
of head and neck, 167–170	for animal photography, 113–116
instructing subject for, 171	for close-up photography, 135–140
photojournalistic, 173–174	for concert photography, 117-121
planning for, 162, 171–176	discussed, 107
poor, 171	for environmental portrait photography,
refined techniques for, 165–170	126–131
traditional, 173	for event photography, 121–126
for wedding photography, 122	for group photography, 131–135
power	for macro photography, 135–140
accessories for, 17	for nature photography, 140–145
battery. See batteries	for night portrait photography, 145–148
for lighting, 50, 52	for outdoor portrait photography,
non-rechargable, 30	149–152
rechargeable, 29, 30–31	for pet photography, 113–116
for SB-600, 29	for product photography, 153–157
for SB-800, 14, 17, 29	for sports photography, 107–112
SD-800 quick recycle battery pack, 17	for still life photography, 153–157
for Speedlights, 29–31	for studio portrait photography,
pre-flashes, 10	157–162
preset white balance, 62, 64–65	for wedding photography, 121–126
pro level Nikon dSLR cameras, 87	for wildlife photography, 140–145
product photography	rechargeable batteries, 29, 30–31
discussed, 102, 153	recycling time (lighting), 52
inspiration for, 154	red-eye
lighting for, 37, 102	of animals, 115
practice exercises for, 155–156	described, 42
space requirements for, 102	red-eye reduction
tips for, 156	discussed, 42–43
prosumer Nikon dSLR cameras. See specific	in SB-600 Speedlight, 18
types, e.g.: D70/D70S	in SB-800, 11
pulse modulation, 31, 76	setup for, 42–44, 43
	reflector disk, 88, 161
Q	release document, 109
quick recycle battery pack (SD-800), 17, 31	Rembrandt lighting, 96
	Rembrandt van Rijn, 96
R	remote flash
R1 kit, 27	channel setting for, 82–83
R1C1 kit, 27	SB-600 Speedlight as, 87
ratios (lighting), 59	wireless, 34-35, 82-83

198 Index + R−S

repeating flash mode	output level compensation settings for,
discussed, 33–34	84–85
in SB-800, 11	power requirements for, 29–31
reversing rings, 140	SB-600 Speedlight vs., 17
right button (SB-800), 16	SB-600 vs., 31
Rocky Mountain Photo Adventures, 186	setup for, 80–81
rotating/tilting flash head	sound in, 36
in SB-600 Speedlight, 18	specs and features of, 10–11
in SB-800, 11	wide-area AF-assist illuminator in, 10
	as wireless remote, 80
S	wireless remote flash of, 35
Santa Fe Workshops, 186	SBR-200 Speedlight, 27
SB-600 Speedlight, 17–23	SB-R200 Speedlights, 135
accessories for, 23	SD-800 quick recycle battery pack, 17, 31
AF Assist function of, 44	seamless paper backdrops, 92–93
color temperature in, 10	seated position, 173
control buttons of, 21–23	SEL button. See select button
discussed, 17	select (SEL) button
features of, 17–18	mode button and, 17
group settings for, 84	on/off button and, 17
Guide Number in, 17, 18, 71	for output compensation adjustments, 38
locking controls for, 41	in SB-800, 16, 17
main parts of, 18–21	sensor. See light sensor
outdoor photography, 102	setup, 34–45
power requirements for, 29–31	for adjusting output compensation, 38–40
red-eye reduction in, 18	for AF Assist function, 44–45
as remote flash, 87	for built-in Speedlight, 81
SB-800 vs., 17	of channels, 37
sound in, 36	of commander unit, 34
wide-area AF-assist illuminator in, 10	discussed, 34
wireless remote flash of, 35	for group settings, 37
zoom position for, 36–37	for LCD panel illumination, 45
SB-800 Speedlight, 10–17	of locking controls, 41
accessories for, 17	for red-eye reduction, 42–44
AF Assist function of, 45	for SB-800, 80–81
channel setting on, 82	for sound, 36
color temperature in, 10	for standby mode, 45
control buttons of, 15–17	for wireless flash photography, 76–78
discussed, 10	of wireless remote flash, 34–35
group settings for, 84	for zoom position, 36–37
Guide Number (GN) in, 11, 72	sexy photography, 174
locking controls for, 41	shade, 103
main parts of, 12–15	shadowless lighting, 96
in Master mode, 80–81, 82	shoe mount. See hot shoe mounting foot
as master (commander) unit, 40, 78-79	shoot-through umbrella, 88
outdoor photography, 102	short lighting, 56

shoulder bags, 104	speedring, 90
shoulders, posing of, 164, 166	split lighting, 96
shutter speed, for action/sports	sports photography
photography, 109	discussed, 107–109
Shutterbug, 187	inspiration for, 109
simplicity, 156	permission release for, 109
SJ-800 colored filter set (SB-800), 17	practice exercises for, 111–112
slow sync	shutter speed for, 109
for night portrait photography, 145	tips for, 112
in SB-600 Speedlight, 18	SS-600 soft carrying case, 23
in SB-800, 11	standard umbrella, 88
small products, 102	standby mode, 45
softboxes	standing position, 173
alternatives to, 91–92	stand-mount softboxes, 90–92
discussed, 90	stands
flash-mount, 90	AS-19 Speedlight stand, 17
for portable studio, 90–92	for backgrounds, 95
stand-mount, 90–91	light, 104–105
studio lighting with, 90–92	in SB-800, 17
umbrellas vs., 88, 90	traveling with, 104–105
sound, 36	still life photography
space requirements	discussed, 153
discussed, 95	inspiration for, 154
for indoor studios, 95–96, 102	lighting for, 75
for outdoor studio, 102-103	practice exercises for, 155–156
for portable studio, 95–96, 102–103	tips for, 156
for small products, 102	wireless Speedlights for, 75
Speedlight. See also specific types, e.g.:	Stofen, diffusion domes from, 136
SB-800 Speedlight	strobes. See studio strobes
attaching, 2	studio. See specific types, e.g.: wireless studio
built-in, 85	studio lighting
choosing, 78	choosing, 49
color temperature in, 64	discussed, 53
in D2H/D2H, 26	placement of, 53–56
in D70/D70S, 25–26	with softboxes, 90–92
in D200, 26	Speedlights vs., 49–53
flash modes of, 31–34	types of, 56–60
flash photography with, 49–53	studio portrait photography
iTTL metering for, 10	discussed, 157
multiple, 76–77	inspiration for, 158–159
power requirements of, 29–31, 50	practice exercises for, 160
repositioning, 2–3	tips for, 161
SBR-200, 27	studio strobes, 49–53
studio lighting vs., 49–53	

studio strobes vs., 49–53 wireless use of, 10, 35

SU-800 commander unit	triangle pose, 166
adjusting output compensation on, 40	tripod, 148
in Commander mode, 40	true macro photography, 140
discussed, 26	TTL (through the lens), 4
subject	TTL BL (i-TTL balanced fill) flash
for bounce flash, 67	+/- buttons for, 22
distance from, 67	availability of, 24
inspiration from, 131	in SB-600, 22, 73
sunlight	in SB-800, 16, 73
bright, 102–103	setup for, 4
cloudy, 103	TTL (i-TTL) flash
timing of, 152	availability of, 24, 25
SW-10H diffusion dome (SB-800), 17	discussed, 31
sync speed	in SB-600, 22
for action photography, 107	in SB-600 Speedlight, 18
auto FP high-speed sync, 25	in SB-800, 11, 16
in D70/D70S, 73, 102	using, 51, 76
exposure specifications for, 73	TTL metering system (3D Multi Sensor
FP high-speed sync, 11, 18, 102–103	metering, i-TTL metering)
high-speed sync, 10	+/- buttons for, 22
for night portrait photography, 145	discussed, 10, 31, 32
PC sync terminal, 15	in SB-600, 22
for SB-800, 11, 15	for SB-800, 14
slow sync, 11	TTL wireless flash, 14, 18
•	11 11 11 11 11
T	U
telephoto lens, 140, 144	umbrellas
test shots, 70	for directional light, 89
TFCD (time for compact disk), 159	for portable studio, 88–90
TFP (time for prints), 159	softboxes vs., 88, 90
3D balanced fill-flash, 32	up button (SB-800), 15
3D Multi Sensor metering. See TTL metering	1
system	V
through the lens (TTL), 4. See also TTL	visual impact, 54
tilting/rotating flash head	F-1-2-, 0-2
in SB-600 Speedlight, 18	W
in SB-800, 11	"warm" colors, 62, 64
time for compact disk (TFCD), 159	Web sites, 185
time for prints (TFP), 159	wedding photography
traditional posing, 171, 173	discussed, 121–122
traveling	inspiration for, 123
with backgrounds, 104–105	posing for, 122, 173, 174
camera cases/bags for, 103–104	practice exercises for, 125
with light stands, 104–105	tips for, 126
with lighting, 49	aps 101, 120
with portable studio, 103–105	
men portubic studio, 105–105	

white balance	modes, 80
automatic, 64	for SB-600, 35
control of, 65	for SB-800, 35
discussed, 62	SB-800 Speedlight as, 80
in flash photography, 62–65	setup for, 34–35
preset, 62–65, 64–65	wireless remote ready light
RAW mode and, 65	(SB-600), 19
setting, 69	wireless Speedlights
wide-angle lens adapter	for action photography, 75
in SB-600, 20	multiple, 75
for SB-800, 14	for portrait photography, 75–77
wide-area AF-assist illuminator, 10, 24, 25	for still life photography, 75
wildlife photography	wireless studio. See portable studio
discussed, 140-141	workshops, 186
inspiration for, 142	The Workshops, 186
practice exercises for, 144	
tips for, 144–145	Υ
wireless flash photography	yearbook posing, 171, 173
with camera, 76	
channel settings for, 82–83	Z
with CLS, 76	zoo, photographing at, 113, 116, 142
discussed, 75–76	zoom
flash mode setup for, 80–81	automatic, 10
group settings for, 83–84	flash-head for, 10
light sensor for, 14	Guide Number and, 11
master (commander) units for, 78-79	zoom button
output level compensation settings	minus button and, 23
for, 84–86	mode button and, 22
setup for, 76–78	in SB-600, 22, 23
TTL, 14	zoom head position
wireless lighting setting, 10	discussed, 71
wireless remote flash	for SB-600, 36–37
channel setting on, 82–83	setup for, 36–37
discussed, 34–35	

Pack the essentials.

These aren't just books. They're *gear*. Pack these colorful how-to guides in your bag along with your camera, iPod, and notebook, and you'll have the essential tips and techniques you'll need while on the go!

0-470-11007-4 • \$19.99 978-0-470-11007-2

0-470-03748-2 • \$19.99 978-0-470-03748-5

0-471-78746-9 • \$19.99 978-0-471-78746-4

0-470-05340-2 • \$19.99 978-0-470-05340-9

0-471-79834-7 • \$19.99 978-0-471-79834-7

0-7645-9679-9 • \$19.99 978-0-7645-9679-7

Also available

PowerBook and iBook Digital Field Guide • 0-7645-9680-2 • \$19.99 Digital Photography Digital Field Guide • 0-7645-9785-X • \$19.99 Nikon D70 Digital Field Guide • 0-7645-9678-0 • \$19.99 Canon EOS Digital Rebel Digital Field Guide • 0-7645-8813-3 • \$19.99

Available wherever books are sold

Wiley and the Wiley logo are registered trademarks of John Wiley & Sons, Inc. and/or its affiliates. All other trademarks are the property of their respective owners.